"The problem of India's Untouchables is not only India's internal problem, but an international problem."

V. T. Rajshekar

DALIT

THE BLACK UNTOUCHABLES
OF INDIA

V.T.Rajshekar

CLARITY PRESS, INC.

Cataloguing in Publication Data:

Rajshekar Shetty, V.T., 1932 -
 Dalit: the black Untouchables of India

Originally published under title: Apartheid in India.
 Bangalore: Dalit Action Committee, 1979.
Includes bibliographical references.
ISBN 0-932863-05-1

 1. Untouchables. I. Title.

DS422.C3R34 1987 323.1'54 C87-090190-7

*Cover : Woman weeping outside Nagpur civil hospital as she waits
for release of her husband's body from the morgue. A stampede
following a police charge against demonstrators killed 113 people.*

Illustrations provided by Dr. Velu Annamalai
Cover design: Diana G. Collier

Clarity Press, Inc.
Suite 469, 3277 Roswell Rd NE
Atlanta, GA. 30305

http://www.claritypress.com

Table of Contents

Publisher's Note

CLARITY PRESS, INC. is delighted to be able to issue this Third Edition of *DALIT: The Black Untouchables of India*. Originally published in India in 1979 under the title "Apartheid in India," and translated into Arabic, Spanish and Japanese, V.T. Rajshekar's treatise on India's most oppressed people first gained recognition throughout the Third World as "the little red book."[1] Two North American editions followed, an expanded edition in 1987, and this third illustrated and updated edition in 1995. In the interim, the issue of Untouchability in India has received increased scrutiny in the United States, Europe, Asia, and through international organizations. The Dalit plight was recognized in a resolution condemning Untouchability passed by the Bangkok Prep-Conference to the World Conference on Human Rights in Vienna in 1993. At annual sessions of the UN Sub-Commission on the Prevention of Discrimination and Protection of Minorities, African-American and Dalit interventions have been coordinated through the International Human Rights Association of American Minorities (IHRAAM), an African-American-launched international NGO in consultative status with the UN concerning formerly-enslaved minorities. Numerous books on the problem of Untouchability have since been published, numerous studies have been undertaken, and an engaged scholarship has emerged.

Why, then, reissue *DALIT: The Black Untouchables of India*? Because this book, a *cri de coeur* by one of the most dedicated activists known to the Dalit community — one whose efforts have proved tireless, insightful, and enduring — touches the heart like none other. Because it remains the book of choice for Dalit activists seeking to arouse public indignation against this most outrageous of indignities against humankind: the notion that the very touch of some might be *polluting*

[1] In reference to its original printing format.

to others. Because it says all that most of us need to know in regard to this social crime against humanity. And because there remains so much to be achieved in the Dalit struggle for human dignity.

The historic collaboration of African-Americans and Indian Dalits took wing with the North American publication of this book linking the systematic oppression of the two, and introduced by IHRAAM Chair, Dr. Y.N. Kly. The mutual awareness of the Dalit and African-American communities has since been cemented, reflected in the ongoing correspondence of African-American popular leaders appearing in the pages of *Dalit Voice,* including a recent guest editorial by African-American historian, Runoko Rashidi, titled "Blacks as a Global Community: Dalits are World's Most Oppressed People," reprinted herein.

DALIT: The Black Untouchables of India is not intended, either by its author or Clarity Press, Inc., to represent a detailed scholarly analysis of the Dalit situation, but rather to isolate and present the central issues pertinent to this long oppression. It comes as an ongoing plea for the ear of the world, from a courageous representative of one of the most exploited and oppressed populations on earth, victim of a centuries-old experiment in forced political integration under conditions of segregation and cultural assimilation.[1]

[1]It is necessary to distinguish between the term integration, and its subsidiary components of assimilation or segregation (apartheid). We use the term "integration" to signify inclusion within a political system or entity under conditions that may or may not be desirable. Thus the South African Black population, for example, was forcibly integrated into the South African political system, where it was maintained in a situation of apartheid until its internal and external resistance efforts, which included effectively marshalling international opinion and assistance, led to the overthrow of the apartheid system. Most of the German American population, on the other hand, is integrated and assimilated. Assimilation may be seen as likely to be desirable insofar as it is sought by the population being assimilated, and achieved under conditions of objective and subjective equal status between the two populations. Neither of these conditions, however, need be present for forced assimilation or ethnocide to occur. As this book shall examine, it is possible for a minority to be forced to assimilate under unequal status conditions and against its desire — usually as a product of conquest. This may occur after or lead to the eradication or negation of its own socio-cultural and historical roots. Forced assimilation occurring under unequal conditions is unlikely to result in a minority's subsequent achievement of objective or subjective equal status with the majority population, and as such must be considered ethnocide for the purpose of domination.

The Author

A graduate of Madras University and author of over 20 books translated into many languages, V.T. Rajshekar worked for 20 years for leading English language dailies before being dismissed because of his efforts on behalf of India's vast persecuted Black Untouchable and Muslim masses. Considered one of India's rare original thinkers, he has attempted to combine the essentials of Marxism and the philosophy of the late Dr. B.R. Ambedkar, a prominent advocate of the human rights of India's Black Untouchables. His works seek to evolve a new indigenous political philosophy to guide the "class-caste" struggle to liberate India's Untouchables from the tyranny of forced integration and assimilation into the Hindu Brahminic society.

The appeal to the world community herein indicates his understanding that in the global village of the late 20th century, oppressed peoples and persons of good will worldwide must combine their understanding and their support, their knowledge and resources, toward the development of a more just and equitable world community.

New Perspectives for the North American Reader

For the North American reader, *DALIT: The Black Untouchables of India* will doubtless offer many surprises, of which we may name just a few: an articulation of the extent of carnage constantly wreaked upon a defenceless population in a country renowned for its apotheosis of the philosophy of nonviolence; a critical perspective on Gandhi, the apostle of nonviolence; an indictment of Hinduism (or more particularly Brahminism) as originally and in essence a political ideology in religious guise, acting to re-enforce the world's most rigid socio-economic and political system, the caste system; an exposé of the historical roots of Nazi racism in the ideology elaborated by the Aryan conquerors of the original black population of the once flourishing Indus Valley civilization, a conquest that marked the introduction of Brahminical Hinduism and the caste system.

Dalits and African-Americans

DALIT: The Black Untouchables of India becomes of even greater interest to American readers when viewed in light of the relation of the

African-American national minority to the Anglo-Americanized[1] majority population in the US. The idea that the African-American minority problem is unique has supported the conviction that the solution to the problem, as proposed by the traditional Negro leadership and reflecting the preferred policies of the Anglo-American ruling class, is to be found in the American solution of civil rights and integration (assimilation). It is the notion of the uniqueness of the African-American problem that has prevented its analysis within the context of minority/majority disputes and practices worldwide, reflected in the norms and principles of customary international law.[2]

This cogent presentation of the situation of the Black Untouchables of India may help to demystify the system of minority-majority relations enforced by the Anglo-American ruling class upon the African-American minority. The existence of a historical pattern of oppression (modified by local historical and cultural antecedents) similar to that introduced by the primitive Aryans and maintained by the Brahminic Hindu caste system in India, in a country which claims to be advocating and practicing the highest ideals of modernity, democracy and equality would, at first glance, appear unlikely. However, closer inspection of actual US governmental minority policies gives grounds for second thoughts.

In India as in the United States, some attempt to deny that the problem of these minorities still exists, asserting that while there may have once been a problem, it has been resolved once and for all by the legal changes instituted at the time of the dissolution of apartheid (segregation) in 1947 and 1954 respectively, and that policies of

[1]While the majority population in the US may be loosely labelled as "white," it is composed of numerous ethnic groups--WASPS, Germans, Poles, Irish, Italians, Jews, Greeks, etc. In reflection of the fact that it is the WASP ethny which holds political and economic dominance among them, the "American" cultural identity to which most "white" ethnies attempt to assimilate is actually that of the WASP. The "majority ethny" is not, therefore, Anglo-Saxon per se, but rather a product of the homogenization and submergence of other ethnic identities in the Anglo-Saxon cultural identity.

[2]For further information in this vein, readers are referred to *International Law and the Black Minority in the US,* and *A Popular Guide to Minority Rights,* by Y. N. Kly, Clarity Press, Inc., 1990 and 1995 respectively. Parallels and similarities to the struggles of black minorities around the world, are also to be found in the situation of other minorities who may not be of African race, such as the Irish Catholics, the French Canadians, the Chechens, etc.

nondiscrimination and affirmative action have assisted its formerly-enslaved minority in a satisfactory progress toward full equality with the majority.[1] While feeling free to pronounce on human rights issues in relation to other countries, both India and the US strongly reject any outside "interference" (criticism) of their own minority relations. Both multi-ethnic states promote the ideal of nonviolence among their oppressed minorities while not hesitating to resort to violence either in relations with other states, or in repression of minority demands. And lastly and most perniciously, both seek to imply that the oppressed minority's current plight is due in some way to its own misdeeds (taken to its insidious ultimate in Brahminism, where a lowly social condition is taken as the just punishment of a transmigrating soul for misdeeds in a previous life).

African-Americans and India's Untouchables share a history of slavery and apartheid (segregation). The Untouchables, originally the African founders of the lush Indus Valley civilization, were invaded and conquered by fair-skinned Aryans from the North. In order to administer a complex web of ethnies and define their relations to the conquered peoples, the Aryans instituted the 4-tiered Brahminical caste system. Based upon birth and ranked by ethny, with Aryans at the peak in the Brahmin caste, and other allied ethnies forming castes of descending order of value, the caste system contained and was addressed to the early Aryans and their allies, who came to be called Hindus. All remaining populations, those who continued to fight the Aryan invaders, lost and were enslaved (the Untouchables), those who fled into the hills (tribals), those whose physical proximity probably remained too far removed from the invaders (backward castes), and those who maintained or subsequently converted to other religions in rejection of their integration and enslavement under Hinduism (Muslims, Christians, Buddhists, etc.) — were outside the caste system and therefore, according to the religious scriptures which came to elaborate, encode and attempt moral justification of the caste system,

[1]That such is far from the case is conclusively established in the recent report to the UN General Assembly by Special Rapporteur, Maurice Glèlè-Ahanhanzo (UN Doc. E/CN.4/1995/78/Add.1, 16 January, 1995.) in which a comprehensive portrait of the disproportionately negative standing of African-Americans in most indicators of social well-being (health, wealth, education, longevity, etc.) is detailed.

outside Hinduism, despite the fact that they were still integrated under Aryan political dominance.

The original black peoples of the Indus valley came to be defined in the terms of their conquerors— as Untouchables— in much the same way as African-Americans were defined in American history books as slaves rather than as captured Africans. The Untouchables were kept in a situation of apartheid so stringent that even the sight of them, to the caste Brahmin, was pollution. As the religious culture of the Aryans gradually penetrated the masses of conquered peoples, Brahminical Hindu gods came to be worshipped by the slave Untouchables in addition to their own.[1] Even though they were forbidden to enter Hindu temples, Hindu philosophy began to permeate their way of thinking — even to the extent that they began to see themselves as having less value than the Aryan Hindus. And yet, by the exclusiveness established by Hindu scriptures, Hindus were in reality a minority population.[2]

They might have remained a minority until today, but for the interlude of British conquest of India. Seeking a local instrument to help it dominate the Indian masses, the British found the Hindus appropriate to their needs. They defined the Hindus as the dominant population, even though huge masses of the population, having neither converted to any other religion nor been accepted by Hinduism (despite their having come under its ideological sway due to the power relations established by the Aryan conquest) were not Hindu.

Upon the evacuation of the British in 1947, Hindus and Muslims were accorded the territories of present-day India and Pakistan respectively. Insofar as democracy was to be established in India, the Hindus faced the prospect of being asea in a multitudinous multi-ethnic state. Desperate to unify India and at the same time maintain their

[1]Given the long weight of Brahminism on the Black Untouchable masses, it has come to be a matter of controversy among Black Untouchables themselves as to what extent they are, or think they are, Hindus, and to what extent they still worship their original gods. Thus, long cultural dominance originally implemented by force has had the effect of blurring or obliterating the cultural identity of India's Black Untouchables, without their achieving true equality or acceptance by the Hindu population even though many feel a part of and identifiy with it.

[2]With the Muslim invasion of India , Untouchables converted to Islam in huge masses, seeking to find justice under the mantle of Islam and at the same time escape their Hindu caste classification as "Untouchables."

dominance within the democracy by assuring that Hinduism had the majority population, they denied Dalit demands for a separate electorate, instead offering them "reservations," a type of quota system assuring them a fixed allotment of civil service jobs offered by the government – – under the condition that they converted, or labelled themselves as Hindus. In other words, India's Untouchables were offered assimilation as the means of ending their religiously enforced apartheid, insofar as their assimilation assured a Hindu majority.

Comparing Indian and US emergence from systemically imposed apartheid, we note that :

1. India constitutionally abolished Untouchability and sought to end the Untouchables' situation of apartheid through their incorporation/ assimilation into a specific religious identity (Hinduism). Some seven years later, the US ended 'separate but equal' segregation not constitutionally, but through judicial decision, seeking to replace the American version of apartheid with universalist notions of civil rights and equality before the law, which under actual existing circumstances promoted African-American assimilation into the bottom ranks of the Anglo-American majority. Neither state envisioned empowering the group newly emerging from the shackles of apartheid in positive terms: as a unique collective entity having a distinct and positive cultural identity with the concomitant internationally recognized right to control of institutions which permitted the flourishing of this identity.

2. India constitutionally instituted an economic quota system through the reservation of a percentage of government jobs for former Untouchables. During the period when African-American protest escalated, the US instituted affirmative action programs,[1] but only allowed these programs a para-judicial rather than a constitutional existence, which has now enabled it to begin an immense rollback of affirmative action[2] without fear of engendering a constitutional malaise.

[1]To be distinguished from quotas by its flabbier definition as an intention to promote African-American equal status without specifically spelling out any concrete action, thereby enabling patterns of apparent compliance but actual avoidance.

[2]Witness the May 22nd, 1995 decision of the Supreme Court of the United States of America to decline to review a U.S. Court of Appeals decision that the Benjamin Banneker Scholarship Program of the University of Maryland, which offers scholarships to African-American students, represents a form of unconstitutional "reverse discrimination" on behalf of African-Americans. The

In India, there is ambivalence among the Dalit population with regard to reservations, some seeing quotas as a legitimate right of the Dalit to their portion of India's national wealth, others questioning them because these economic lures have induced those once designated as Untouchables to assimilate into a system where they are permanently "on the bottom," as they were allowed into Hinduism only as members of the 4th or lowest (failing Gandhi's suggestion of the creation of a 5th) caste.

In the United States, however, governments have only acceded to African-American demands for compensatory or "catch-up" rights, while the notion of quotas or any permanent (constitutionally-enshrined and institutionally-implemented) minority share of national wealth and power has not been considered. Forced assimilation has been attempted through busing programs and the "integration" of institutions, which has led rather to a break-up of African-American control over those institutions established for them in the period of American apartheid, than to significant African-American input into contemporary majority-controlled institutions. The net effect of these techniques has pointed toward a devaluation or disassembling of the community structures of the African-American minority, possibly leading toward their disappearance as a distinct collective or nationality, evidenced in the existence of thriving community structures and institutions. However, it has also led to a renewed discussion throughout the African-American national minority of their cultural specificity.[1]

3. In both countries, the charge of "reverse discrimination" has been used to contest the preferential transfer of social benefits to members of these oppressed minorities, in clear contravention of the

Court of Appeals ruling held that the university scholarship program violated the constitutional right to equal protection under the law of Daniel Podberesky, who met all qualifications for the full tuition scholarshiip other than race. By declining to review the Court of Appeals decision, the US Supreme Court decision represents yet another in an on-going series of judicial and legislative efforts to roll back US programs of affirmative action, such as the proposed California Civil Rights Initiative, scheduled to be on the ballot in March 1996, which seeks to bar preferential treatment in state employment, education and contracts, etc.

[1]Witness, *inter alia*, the creation of African-American schools in Milwaukee and Detroit, the rise of Afro-centrism, and the increasing replacement of the racial designation, Black Americans, with the ethnic term, African-Americans.

obligations of both countries as signatories to the International Convention on the Elimination of All Forms of Racial Discrimination, which specifically militates against the reverse discrimination notion (Article 1[4]).

Assimilation, Quotas and Self-Determination

Given the constitutional enshrinement of reservations or quotas for the Dalits, a sector of this Indian minority has achieved some economic gains. But this has raised questions. Apathy has been generated within the small privileged sector of that community which was enabled to take advantage of the quotas. This small privileged elite has been reluctant to act on behalf of the masses still dispossessed, and its leadership, or lack of it, has made this apathy permeate the masses of the community. Many contend that this elite has, in fact, ceased to identify with the community from which it sprung. While quotas as instituted in India have provided an economic springboard for a small minority of the Dalit or Black Untouchable population and have thereby, to some extent, led that elite to disavow its community, they have not solved the problem of equal rights and human dignity for the Dalits— not for the masses, not even for the elite who, despite having achieved economic status, despite their conversion to Hinduism, still suffer from the discrimination and antagonism attached to their prior existence as Untouchables.

This problem stems, as V.T. Rajshekar points out, from their being forced to assimilate into a society which is already the most rigidly stratified in the world. Therefore, even though any legal discrimination against Untouchables as out-castes (i.e. outside the caste system) or polluted, is attacked by the constitutionally-delineated reforms, these reforms exist more on paper than in the actual lives of the masses concerned. The fact that the society into which the Dalits are supposedly to be integrated is itself profoundly rent by class and caste, remains of crucial importance. On what level is a formerly despised minority likely to be accepted in such a society's ideological structures, which determinedly enforce hierarchy among its own members?

The fact that such a solution holds little attraction for the Dalits is evidenced by the fact that large masses have chosen instead to convert to Islam or Buddhism or Christianity. Such conversion does not come without cost; it means the surrendering of any claim to the benefits of

quotas. That the conversions continue at increasing rates emphasizes the relative value that the Dalits accord to the economic palliatives offered by quotas as opposed to the equality of human dignity philosophically endorsed by the three egalitarian religions.[1]

An additional option, however, has arisen to address the collective plight of the Dalits. This option, fuelled by despair at the prospects of equality under Hindu Brahminism, seeks the creation or recreation of a distinct Dalit political entity or *Dalitistan* as the solution to the Black Untouchable search for human dignity and equality. Within this framework, the Dalits would shake off the mental and physical bonds of Hinduism, and would work to rediscover and recreate the lost and still-existing elements of their original culture. Forced assimilation of the African-American minority into the Anglo-Americanized majority culture, under similar conditions of objective and subjective unequal status, is proving equally inauspicious for that minority's ever achieving equal status with the majority. Among the African-American population, too, there has arisen the demand for a distinct political entity, voiced most consistently by various nationalist as well as Islamic groups.

Perhaps no other right has been so highly valued and widely sought by oppressed peoples worldwide as the right to self-determination. Yet for formerly-enslaved minorities such as the Dalits and African-Americans, who have endured centuries-long systemic discrimination and continue to be its victims despite recent measures providing for nondiscrimination by law, the key to achieving and sustaining equal status may lie in the possibilities for collective empowerment afforded by minority rights (the right to develop as unique cultures, which may require control of their own socio-economic and/or politico-legal institutions *within* the multinational state) *in addition to* civil rights/ nondiscrimination.

CLARITY PRESS, INC., 1995

[1] However, for those who have converted to Christianity, the caste system still affects the new community. See A. Antony Das Gupta "Why Dalits Prefer Islam, Not Christianity," *Dalit Voice,* April 16-30, 1987. Increasingly, those in the Dalit community seeking equality view Islam as being able to provide an appropriate guide and shield for the construction of a new, thriving and egalitarian Dalit culture.

Foreword

Perhaps only the Jews have as long a history of suffering from discrimination as the Dalits. However, when we consider the nature of the suffering endured by the Dalits, it is the African-American parallel of enslavement, apartheid and forced assimilation that comes to mind. The present heated African-American debate about integration/assimilation[1] or some form of self-determination is influenced by this history. Proponents of both philosophies suggest that their ideals would lead to equality and equal status for the majority of African-Americans. Although the integrationist/assimilationist philosophy was always promoted by middle and upper class Black Americans, while some form of socio-political independence was always promoted by the vast underclass majority, it was always the integrationist/assimilationist philosophy which was followed in the end by the masses of African-Americans.

The reason for this seems to lie in the fact that it was only the integrationist/assimilationist philosophy which was acceptable to or taken seriously by the Anglo-American power structure; therefore, the implementation of any other option might necessitate the threat or use of an armed struggle, which the vast majority of African-Americans were undoubtedly convinced could not be achieved. In addition, the rewards of the US system — the good job, the beautiful home, new car, high social status and popularity etc. — went only to those who adopted the essentials of the integrationist/assimilationist philosophy.

Because both philosophies were considered by the masses of African-Americans to have as their end goal the achievement of equality

[1]The words integration and assimilation are used interchangeably in the US. However, it is well to note we use integration strictly in its political sense: the bringing together of two or more communities or nations under the authority of the same power (imperium). Assimilation, on the other hand, has essentially a sociological significance having to do with the process of acculturation between two or more communities, etc.

between the races, both philosophies have been and still are considered legitimate choices by the masses, with a strong edge given to the integrationist/assimilationist philosophy because it is considered more realistic, i.e. more attainable.[1]

The importance of the book *Dalit: The Black Untouchables of India* by V.T. Rajshekar, is that it suggests that just the opposite is true: that the acceptable, therefore easy, integrationist/assimilationist concept (as developed and practiced in the US) is not a way at all, but a deception, a process that leads not to equality but rather encourages the maintenance of a caste or class hierarchy in society wherein total economic, socio-cultural and political power may be legitimately and theoretically forever centralized in the hands of a dominant race or ethny. A society where "integration" or assimilation serve only to eliminate the minorities' social power centers (institutions) and cultural awareness that serve to prevent the government elite or the dominant group from achieving total legitimate centralized social control, including the acceptance and complete institutionalization of its cultural concepts of "white superiority," is a society in which racial exploitation can be realized through caste and class, with their accompanying rewards, duties, values and human worth— or lack of same. In Marxist terms, it would simply mean a society wherein forced cultural assimilation was applied under conditions of objective and subjective inequality between the majority and minority nationalities, for the purpose of legitimizing eternal domination and exploitation of that nationality or minority by eliminating its political and *de jure* existence as a separate entity from the majority. If this is the case, the US and India are not unique. This was attempted by each colonial power before its being obliged to accept a degree of political emancipation.

Mr. Rajshekar prepared his book as a clear warning to the Dalits, and it serves as the same to their fellow oppressed African-American minority in the US.

[1]It is considered more attainable simply because the vast majority of African-Americans have been convinced that the Anglo-Americanized majority will not let them do anything else, and that they do not possess the power to prevent the Anglo-Americanized majority from forcing them to accept whatever they may demand. The power of the traditional Negro leadership to secure the obedience of the African-American masses results not from a belief in the moral, intellectual or representative claim, but simply from the belief that they can

Integration or intergradation?

If there is one universal political paradigm that the politics of the traditional American negro leadership has re-enforced, it is that the desire for peace and nonviolence has no moral, social or political value where it is perceived that those who seek nonviolent solutions do so out of fear, cowardice or incapacity to seriously think otherwise. Where a people perceived as morally and intellectually inferior and materially impoverished always opt for peace at any price, their act, far from denoting the moral high ground, denotes cowardice and solicits further contempt and oppression. This observation as reinforced by the success of Dr. Martin Luther King's challenge: "End official segregation by nonviolence — or else" at a time when the African-American "riots"[1] were demonstrating the will and courage to implement King's "or else").

Thus in the truest sense, a leadership's decision to do what is necessary is a decision to be free, just as the decision not to do what is necessary is a decision not to be free. If appropriate action is necessary, then the act is the act of being free with equal status. This freedom and equality is achieved at the very moment of the necessary decision and will endure so long as both sides are obliged to reach an honorable and mutually acceptable understanding.

The word integration has no useful meaning outside of its application in the society or state concerned, i.e.. Suzy is as Suzy does.[2] If we

influence or restrain the Anglo-American "gods," and thus protect the African-American individually from arbitrary and unjust aggressions. Thus the power of the traditional negro leadership is based on the fears of the African-American masses, particularly the fear of being excommunicated from the protection of the group as signified by the traditional negro leadership, and left to fend for oneself in a hostile Anglo-American world.

[1]Many African-Americans consider the activities during the 1960's to be insurrections, not riots.

[2]This is true even though the direct causes of the minorities' inferior situation can be directly traced to the minorities' educational, social, economic or political weakness. Such weaknesses may exist because of the historical oppression of that minority, but above all, they exist in comparative relation to the model forced on it by the majority. Alter the relation or change the model to favor the minority, and the perceived weaknesses may lose their significance.

observe that a state has given political and cultural autonomy or nationhood to each minority while providing a political institution for a broader equal-status unity, then this is what integration means. *Likewise, if we observe that in every part of a state, a minority exists and is placed in an inferior cultural, socio-economic and political position and viewed as an "underclass," second class citizen, lower class, shudra, Untouchable or what have you, then this is what integration in that society means.*[1]

Whatever social situation we have objectively observed integration, nonviolence, peace or "Gandhism" to have produced and maintained in a particular society is what it means in that society. The politically undefined ideals of nonviolence and integration can be used like any other undefined concept to reduce or maintain an ignorant and misled minority into a permanent position as an exploited "underclass," or in the case of India, "Untouchable." As noted in a recent United Nations publication:

> If we interpret "caste" in a general way, i.e. as referring to powerless groups of either religious or ethnic distinction, we see that the underclass is made up of such individuals — whether in the West or East, as shown by the racial proportion of homeless in the U.S. (which far exceeds the proportion of Blacks and Hispanics in the U.S. population) or the lowest Hindu caste of India.[2]

If this is what is happening in the US, *then the African-American leadership does not have a legitimate choice between integration or some form of self-determination, but rather a choice between the African-American minority's becoming the bulk of a permanent underclass or some form of self-determination.*

[1]The meaning of integration in the US must be sought empirically. To know what it means, we must carefully observe and analyze what the US ruling elite is actually doing or allowing to occur, bearing in mind that during the colonial period of India, Africa, Asia, etc., the mother countries also claimed to be in the process of integrating and assimilating the oppressed peoples of their empires.

[2]Graeme Newman, "Crime and the Human Condition," in *Essays on Crime and Development,* United Nations Interregional Crime and Justice Research Institute, Publication No. 36, Rome, July 1990.

The Direction of the Present Recognized Leadership (1950-1990)

In a salute to the African-American leader El Hajj Malik El Shabazz, Kattie M. Cumbo writes:

You opened my eyes
Offered me a chance to see

I saw
and cried
Then I closed my eyes

because
I did not wish to see

Now, I look with eyes that see
but I am sad...

'The truth is that most African-Americans in American leadership positions know the situation the masses of their people are in, and also fully understand that perhaps a caste system is being established. But when they first opened their eyes and looked, what they saw was so disturbing and ugly that they decided to close their eyes, look the other way, or chase a dream. Of course, their dream, in essence, is that what is, is not what they see.

The human condition is such that once these bright individuals saw the real alternatives facing them — to call attention to the obvious or to chase an individualist dream, to lose social and political status and economic security not only in the majority society but in African-American society as well — the vast majority opted for individualism, Americanism and materialism, even if it may mean the solidification of a permanent class/caste system where the social hierarchy may range from Anglo-Americans at the top, followed by Anglo-Americanized European immigrants, followed by Spanish Americans, with black Anglo-Saxonized African-Americans forming the upper layer of a vast underclass formed mainly of African-Americans.

These leaders realized that by opting for the American Myth above the American reality, they would secure a place for themselves and their families away from the horrors of life among the "underclass" or "undercaste." Although black, they became *American* leaders instead

of African-American leaders by opting for Americanism. In other words, while the African-American population saw them as black leaders and propelled them into power by the strength of their efforts and votes, once in power, they saw themselves as representing the whole or majority of the electorate. The black mayors, for example, are obliged to see themselves as representing the whole of the city in which they hold office, and as such, chiefly the interest of the Anglo-American communities which maintain financial and institutional power, rather than primarily the interest of their electoral constituencies, the African-American community. *The problem is not that they see themselves as representing both interests, but that the interest of the Anglo-Americans in maintaining cultural, economic and thus political domination is diametrically opposed to the interest of the African-Americans to free themselves from that domination.* Also, the policies of such leaders are obliged to relate to and coordinate with the policies of the national Anglo-American power structure. They soon come to realize that their personal interest and security can best be secured by keeping things in place (maintaining the status quo), i.e. representing Anglo-American interests and catering to African-American emotional demands by encouraging change in keeping with the acceptable liberal Anglo-American tradition regardless of African-American needs or demands.

In order to maintain their status, such leaders find themselves in a position wherein they must always act in the interest of the dominant ethny, while convincing the African-American minority that the interest of the dominating class or caste is also their best interest. *The skill with which they have been able to perform this role over the past one hundred years is the most dynamic proof that the intelligence of "blacks" is equal to that of "whites."* Their goals are the same as those of all American leaders, thus they are in the truest sense American leaders, although they are black and not at the top of the hierarchy.

Of course, the ignorance, fear and useless policies of the traditional negro leadership are a direct product of the whole situation of economic, social and political domination and paternalism of which they are also victims. Although the only way to end their victimization as well as that of the African-American masses involves taking risk by encouraging the masses to take risk, they instead seek security and advise the masses to seek liberation through education. Yes, but whose education? The US educational system, like that of most states, operates to preserve the status quo-interest of the socio-political

systems in place.

The truth is that the traditional negro leadership fears the risk involved in a real struggle for freedom, and instead they rush to achieve security. By presenting themselves as defenders of freedom, they give their doubts, fears and prejudices against the black masses an air of profound sobriety. But because they confuse freedom with the maintenance of the status quo (system), if freedom for the African-American masses threatens to place the system or status quo in question, to them this seems to constitute a threat to freedom itself. Freedom yes, but whose freedom? *Their* freedom to benefit from the oppression — to profit socially, economically and politically from the domination and exploitation of the African-American masses.

Although the policies of this leadership almost never meet the test of good common sense within the context of the reality of oppression, and likewise have never worked to bring about the equal status of African-Americans, the assumptions and premises upon which these policies are based are never questioned, analyzed or changed. Each traditional negro leader explains the results of his policies within the context of his truth, and considers anything that is not "his" truth a lie. *"They suffer from an absence of doubt."*

Thus the traditional leadership, instead of striving for liberation, have themselves become oppressors, or "second class" oppressors. Their ideal is to be free and successful, but for them this means being like the Anglo-American oppressors in relation to the African-Americans. This is their model of freedom and success. Their perception of themselves as part of the African-American oppressed is impaired by their submersion in the reality of oppression. Usually when given positions in the system, they become more intolerant of the needs, culture and demands of the African-American masses than the Anglo-American ruling elite itself.

While dominated by the fear of freedom and the fear of fear, the traditional negro leadership refuses to appeal to others, or to listen to the appeals of others, or even to the appeals of their own conscience. They discover that without freedom, they cannot exist authentically. Yet although they desire authentic existence, they fear it. They are at one and the same time themselves and the oppressor, whose consciousness they have internalized. For this type of leadership — Negro, Dalit, what have you — to be is to be like the ruling elite.[1]

[1]This section on the Negro leadership denoted by single quotes is an adaptation of Paolo Freire's *Pedagogy of the Oppressed* (Continuum Press, New York, 1986) to the actions and functions of the recognized Negro-American leadership until the 1990s.

Such leadership, in its unending call to the masses for nonviolence and its renunciation of self-defense, prefers to forget that violence is often initiated by those who oppress, who exploit, who fail to recognize others as equal human beings — rather than those who are oppressed, exploited and unrecognized. It is not the unloved who initiate disaffection, but those who cannot love because they love only themselves. It is not the helpless, subject to terror, who customarily initiate terror, but the violent who with their power continue to create the concrete situation which perpetuates past violence into the present and future. It is rarely the despised who initiate hatred, but those who despise. It is not those whose human rights are denied who negate man, but those who denied those human rights. Force is most often used, not by those who have become weak under the preponderance of the strong, but by the strong who have emasculated them. They forget that it is only the oppressed who must strike the first blow by freeing themselves, so that they can free their oppressors.

Having turned their backs on their own human rights and human dignity as well as that of the African-American masses, and opted for security in the status quo above all, they necessarily see freedom in strictly materialistic terms. Money is the measure of all things, and profit the primary goal. For the traditional African-American leadership, what is worthwhile is to have more things — even at the cost of the African-American masses having nothing. For them, to be is to have, and to be the choice of the haves. Thus, since it is the Anglo-American ruling class that controls all the things they wish to have, for them, to be means to be under the control of the Anglo-American elite, to depend on them emotionally as well as materially.[1]

Perhaps the most difficult political concept for African-Americans to realize is that most of the blacks put in leadership positions must become American leaders, *not African-American leaders representing specifically African-American interests, keeping in mind that African-American interest would include appropriate erosion of Anglo-American interest. In the position of American leaders, they are unable to be seriously concerned with bringing about a functional equality or equal-status relationship between African-Americans and the Anglo-Americanized majority.*

[1] Many of the ideas in this paragraph were originally expressed in *The Pedagogy of the Oppressed, supra.*

Equally difficult for African-Americans to conceptualize is that over time, their collective human rights can be practically and legally forfeited if the leadership they accept, or acquiesce to, continues to accept their conditions of inequality and inferior status as the norm. In a practical sense, an effective collective identity can fade from the memories of its inheritors, so that original cultural ideals, history, practices, etc. — the source and positive rationale for a minority's freedom from the direct socio-political control of the majority — may be lost forever. In a legal sense, in order to quality for the minority protection accorded national minorities under international law, minorities are required to evidence the will to express and maintain their collective identity. Such a will, if expressed and supported by the majority of the oppressed population, can gain the necessary aid and support of the international community.[1]

African-Americans accept as normal the fact that the efforts and programs of the most important of their real African-American leaders — W.E.B. DuBois, Marcus Garvey, Denmark Versey, Nat Turner, The Honorable Elijah Muhammad, Dr. M.L. King, Jr., Malcolm X, Louis Farrakhan, Warid Mohammed, Silis Muhammad, Jesse Jackson, Imari Obadele, etc.[2] — have never been taken seriously by the US government or by the traditional negro leadership.[3] This *real leadership has therefore had no institutional means or power to assist or represent the needs or goals of the people who created and recognized them as leaders.* In fact, these real leaders of the masses of African-Americans are themselves represented by the traditional negro leadership when it comes to a significant voice in US government or, until recently, international institutions.

The traditional negro leadership, by accepting a forced assimilationist program as a serious means to achieve equal-status relations for the masses of African-Americans when they knew it meant ethnocide ("living

[1] For further discussion of minority rights, see Y. N. Kly, ed., *A Popular Guide to Minority Rights,* Clarity Press, Inc., Atlanta, 1995.

[2] Dr. Martin Luther King, Jr. may have been the exception to this rule, but he was assassinated before he completed the development of his program.

[3] All real African-American leaders come into leadership positions through the socio-religious institutions of the African-American ethny, while the traditional negro leadership obtains American leadership positions through the socio-political institutions controlled by the dominant ethny.

the dream"), have prostituted their degrees and high social status to the service of government elites' disinformation, exhausting the energy of serious African-Americans in illusory projects. When the African-American community needs above all a leadership committed to African-American development, the slim resources and energy of the community is spent in voting for *black politicians who will become American politicians,*[1] energy that might have gone towards the establishment of an independent African-American controlled political party or democratically elected African-American national council, an African-American TV/media network, national product distribution system, etc.

Such an established negro leadership is always willing to see and explain reality according to the theories and philosophies it knows will be socially acceptable and personally beneficial. Thus, any clear statement of the obvious with regard to the situation and needs of the African-American masses cannot be expected from them. It would mean a repudiation of all the years they have spent in learning the acceptable theories (and thus rendering their education, experience and past orientation economically and socially unprofitable.)

It is only natural that individuals in such leadership positions, totally materially and socio-politically dependent on their acceptability to the Anglo-Americanized elites, should *sacrifice their intellectual integrity when it comes to the struggle for African-American equality.*

Such leaders, for example, can be seen as totally committed to the philosophy of Gandhian nonviolence and extreme US patriotism when speaking of the struggles of the African-Americans for self-determination, while at the same time they are totally committed to armed struggle when speaking about US defense of its interests in Iraq.

The point here is to question whether the philosophies of the traditional negro leadership are seriously committed to any such high

[1]The political priority of all American politicians must necessarily be limited to maintaining and working within the system in place. After all, the system is responsible for their official positions as leaders, and it is that same system that makes it possible for them to maintain and profit from their position. The crucial factor is that the electoral system or party is controlled by the dominant group, and the maintenance of this system means the maintenance of the dominant group in place. Thus, the election of black politicians means the extension of the Anglo-American political and social control deeper into the African-American community.

moral principles of nonviolence or self-defense, or if they are really committed to taking a position, by any means necessary, that is acceptable to the dominant majority. Similarly, are such leaders committed to the principle of integration in a way that will produce equal status between the Anglo-Americanized majority and African-Americans, or are they committed to integration in any way which may be acceptable to or preferred by the Anglo-Americanized majority?

US "Integration": Just a Strategy?[1]

It must be obvious to the Anglo-American ruling class that, given the situation of inequality, the more the African-American minority approaches the values of Anglo-Americanized society (which presently supports the use of meaningful struggle in affirming its values or "American ideals"), the more likely will become the possibility of bitter struggle between the African-American minority and the Anglo-Americanized majority.

If this contradiction is viewed in conjunction with the fact that the US is losing control over international institutions and the international community, it is natural to conclude that , as the world system moves from bi-polar through mono-polar to multi-polar, the ruling class is more interested than ever before in assuring its control over its domestic populations.[2] It is reasonable, therefore, to ask, as Mr. Rajshekar does in the similar case of the Black Untouchables in India: does the philosophy of an undefined integration without social, cultural or economic equality simply promote a more permanent form of domination?

[1]It is clear that the US black minority has always been politically integrated, even while segregated. The choice of the word "integration" rather than "assimilation" to designate the support process whereby African-American equality is to be achieved may be a strategic decision prompted by the awareness that it may be harder to generate African-American support for the notion of assimilation, with its connotations of loss of African or collective identity, etc.

[2] Witness the recent rise of the Republican right and its policies, and similarly the appearance of works such as *The Disuniting of America: Reflections on a Multi-Cultural Society* by Arthur M. Schlesinger.

From Nation to Underclass: The Final Defeat

A historical summary of why nations or peoples survive in victory or defeat, why the materially strong often lose or why the materially weak often triumph, would indicate that *all power comes from the will. The will, within material limitations, invents the means, and it is often said that man's will comes from God.*[1] Be this as it may, the nonreligious realize that a nation or a people can be manipulated into a circumstance that will cause them to alter their consciousness, the way they see themselves and others. We are told many stories of African-Americans in South Carolina who have been placed under such Anglo-American socio-cultural and economic environmental pressures that they have come to believe that they are poor and exploited because of something their parents did or something they did, in this or in a past life. "If such and such had not happened in the past, I would be white and not have all these problems." *Thus the will to win, to have equal human dignity, is converted into the will to be good, to obey the rules of the oppressor, regardless, so that in heaven or the next life, they can be equal to or the same as the oppressor.* Is this not what V.T. Rajshekar tells us the Hindu Brahmin has long taught to the "untouchable" Dalit?

Inequality of any kind should never be accepted mentally, and this is why the oppressed, by not accepting, often provoke the use of violence by the oppressor. But *for a people in a position of oppression, the unjust use of force (violence) by the oppressor is a victory,* because it means that the oppressor has been unable to control the will of the oppressed and must now resort to the use of a method that will harm himself as well as the oppressed, and will clarify the nature of the relationship between them. *In short, the oppressor is forced to pay a price to maintain his oppression, and must accept that he is an oppressor.* This permits internal awareness, the unity of the oppressed, and the possibility of greater internal and external alliances.

[1]Thus, to determine the will of the oppressed has been the eternal quest of every tyrant or oppressor in history. To succeed assures internal oppression, and in this way the oppressor can become a God, the God of the oppressed. This is the main reason why it is absolutely forbidden in such religions as Islam to accept oppression. To do so would be to violate the fundamental pillar of faith: that there is no God but God.

The struggle of an oppressed minority always includes, among other things, an inter-minority class struggle, if for no other reason than that a small portion of the oppressed minority is always solicited to assist the oppressor group in maintaining its domination. As a part of its required functioning as well as its reward, this small portion comes to hold the main positions of socio-economic and political influence within the minority, as institutionalized from outside it by the dominating majority. They become, in short, an upper class of the oppressed minority (Kingfish).

Given that this small upper class will hold a position among the oppressed minority of considerable influence and authority, attempting to ensure that the socio-cultural environment and material circumstances of the masses cannot change, all large scale or significant economic, social or cultural development by the minority is impossible without its first resolving the political problem posed by the treacherous leadership of its own upper class.

All large scale or significant economic, social or cultural development is impossible without simultaneously or first resolving the political problem of oppression, domination and exploitation. Economic, socio-cultural and political development are not independent of each other, but rather are interacting, intersecting and mutually dependent upon the attainment of or search for (by any means necessary) an appropriate degree of self-determination. Similarly, integration or separation are not necessarily mutually exclusive. Either one may include the other. The question is not to assimilate or to separate, but to fully implement human rights, to achieve political, cultural and economic freedom and equality. Such an equality or freedom may include doing neither, either, or all.

Culture and Oppression

In the world today, apart from a few small isolated aboriginal tribes in places like the Amazon basin, etc., there are no pure cultures. Since the very dawn of history, peoples, nations, empires and states have, for various reasons and by various means, changed and exchanged cultural characteristics. "Greek" civilization borrowed and learned from Egyptian and North African civilization, "Roman" from Greek and Hellenized North Africa, and so on through Byzantine and Islamic civilizations to that of medieval and contemporary Europe. Once there

was a Holy Roman Empire dominated by the German ethny, which wanted to be and saw itself as Roman. In America, African-American music, dance and fashion has as decisive an influence on many areas of majority culture as Christianity, say, has on African-American culture.

Thus the problem faced by African-Americans and by the Dalits (black "untouchables" of India) is not simply one of cultural assimilation, but rather one of *forced* cultural assimilation, which historically occurs only for the purpose of domination and exploitation. It was an essential element of the state and segregation period in the US.

It is often said that today African-Americans have no culture separate from that of the Anglo-Americanized population. However, this is not the case. African-Americans, like any other nonassimilated people in the US, can be said to be the sum total of their ethny's historical experiences both before and after they arrived in the US, as perceived and acted upon by themselves and objectively observable by others.

It is also often said that African-Americans lost their African culture completely. While this may be historically true, for the most part, at the individual level, it can be historically demonstrated that collectively they have always acted within the framework of their African cultural orientation. The fact that they know that they lost their African culture at the individual family level is itself the proof that it is not lost at the collective level. Otherwise, how would they feel that anything was lost? Thus it is this collective African cultural consciousness that is most important, because individual culture and history can be regenerated like the broken twig of a tree from the branch of collective cultural consciousness. The recent Gullah Festivals in South Carolina are a reminder of this regenerative capacity.

This is why a ruling elite which wishes to destroy the existence of a people or nation can appear to accept them on the individual level while practicing total intolerance for their collective cultural identity, thus practicing what may be called ethnocide. The oppressor attempts this individualization of the African-American minority while at the same time ignoring its collective political movements (as exemplified by the major mass movements and allegiances of this ethny — from Nat Turner, Marcus Garvey, The Honorable Elijah Muhammad, Silis Muhammad, Dr. King, Malcolm X, Louis Farrakhan, Warid Mohammed, Jesse Jackson, Imari Obadele, etc.) and attempting to re-establish for the uprooted individual the oppressor's subjective visualization or invention of the collective (the negro) to which that uprooted individual is said to

belong. Although the subjective or Anglo-culture-biased invention is given official sanction and therefore complementary power and influence within the community of the oppressed, it may not succeed because it takes only a few conscious individuals to highlight the oppressor's culture-biased visualization of the oppressed to the masses for what it is: a proof and symbol of their oppression.

Throughout African-American history, and increasingly more recently, we have seen individuals and small groups taking the step of changing their names from those forced on their ancestors to African and Muslim names of *their* choice. This is a natural and very healthy sign. In the truest historical sense, it has nothing to do with hatred of the Anglo-Americanized majority or rejection of the society in which they live, although Anglo-Americans may see it as such an expression. Such actions are fundamental the effort of individuals to put themselves in harmony with themselves and their real collective identity. It is as natural as the plant stem generating new flowers, without which the collective would be unable to develop, and would become truly unmanageable. While the oppressor may want to invent and control the nature of the oppressed's collective identity, the actual death of a collective identity would probably serve neither the identity interest of the African-American minority or that of the US government. Thus both the oppressed and the oppressor have this need in common. The conflict concerns which one will energize and determine the nature of the minority's collective identity.

The "Breaking-In" Process Continues

Living as a minority under the pressures of forced assimilation and physical segregation, while being the only condition of life the African-American has ever known, remains extremely stressful and difficult. This can be seen in the minorities' higher rate of high blood pressure, heart disease and other anxiety or stress-related diseases, and in the higher degree of community and family dysfunction. In order to cope in a society where all aspects of their daily lives are dominated by the dictum of the Anglo-American ruling elites,[1] most African-Americans develop some form of reality avoidance technique as well as a wholly emotional or religious superficial adherence to Anglo-American social

[1]Most of the minority's history, environment and living conditions—their eating habits, marriage customs, consumer goods, family and intra-family relations, etc. — are, to say the least, different.

and political dictums, whether or not they make sense or are understood. The latter habit or need of the African-American masses is often referred to by their own true leadership as being against their true nature or the nature of things. However, no matter how much the true African-American leadership asks the masses to change or act in their own collective interest economically, socially or culturally, the masses of African-Americans always remain in the same condition. This is simply because the reality of the political structure and environment imposed from above by the Anglo-American government through its negro American leadership will not accommodate the necessary change.

In the most fundamental sense, given the weaknesses of their true leadership in not focusing the people's slim resources against the first and most important enemies — the traditional negro leadership — the African-American masses are acting in the best interest of maintaining their mental, economic and social balance. *Because the African-American masses cannot be asked to change personally and individually without asking them to change the politico-socio-cultural structure (including the traditional negro leadership) currently in place. Both their material welfare, socio-cultural and physical health depends on their American as well as real leaders coming to understand this necessity and establishing democratic processes that will permit leadership change.*

More than one hundred years ago, a well-known sufi sage, Hazkat Inayat Khan, wrote:

> The harmony of the body and the mind also depend upon one's external life (environment) as well as the food one eats, the way one lives, the people one meets, the work one does, the climate in which one lives. There is no doubt that under the same conditions one person may be ill and another may be well.
>
> A person who revolts [as an individual] against the conditions around him is likely to bring upon himself disorder and subsequent illness.

Interestingly, Mr. Khan did not say that some or a relative few could not change individually without changing their environment, but that most of the masses could not. Thus it is the duty of those who escape the socio-psychological consequences of an oppressive environment

or politico-socio-economic structure to act in such a manner as to assist the masses in changing that environment or its institutions. It is in this way only that they will be able to change and come into harmony with themselves. Thus the African-American masses do and will continue to acquiesce and act in accordance to the dictates of their real socio-political environment. Historically this is always the case — until their real friends and leaders are able to effectively challenge the traditional negro leadership and societal institutions, and release the abilities of the masses to find a new way — by any means necessary. For a true leadership to attempt to do otherwise would be destructive and morally obscene.

Dalit: The Black Untouchables of India by V.T. Rajshekar obliges US blacks to reflect on exactly where present policies are leading. What really will be their future in the US? Is it possible that after years of continuing to choose the most easy and acceptable path, they can become the future shudras or Black Untouchables of America?

The Brahmins of India may have been the first ethny to systematize exploitation through racial domination and the philosophy of Aryan white superiority; we truly hope that the US is not to be the laboratory for another such experiment.

Y. N. Kly
1987, updated 1995.

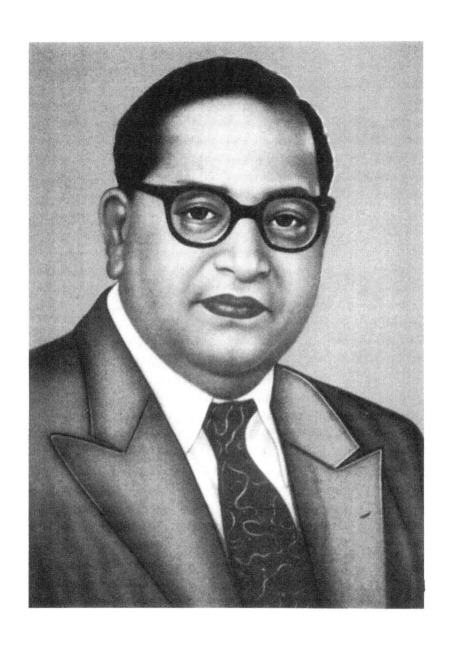

Dr. B.R. AMBEDKAR, renowned leader of the Indian Dalits.

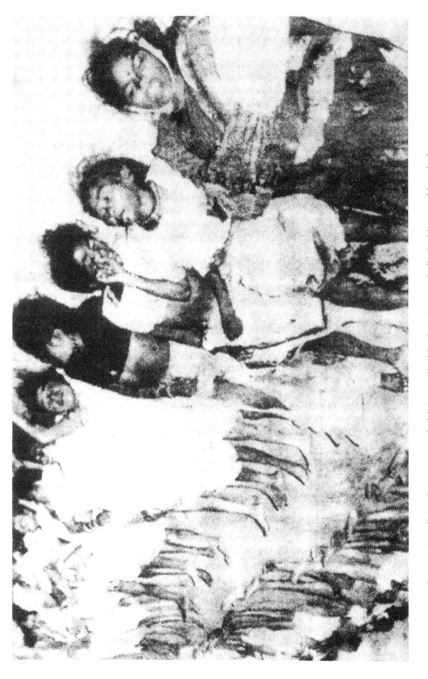

Rows of bodies of women and children killed in the stampede lie in Nagpur Hospital

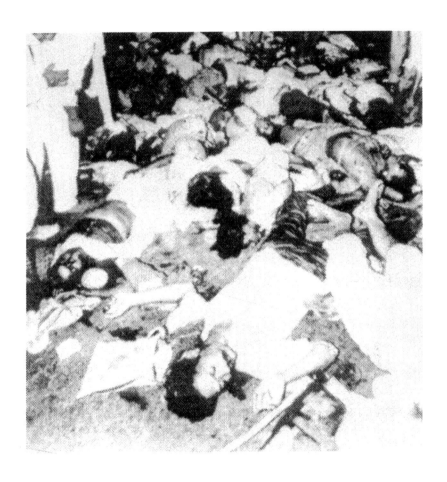

The scene at Morris College Gate in Nagpur after a stampede which resulted in the death of 113, following a police lathi charge on Adivasi Gowari Samaj Sanghatan workers who were marching towards Maharashtra legislature building pressing for scheduled tribes status. *Indian Tribune,* December 10, 1994.

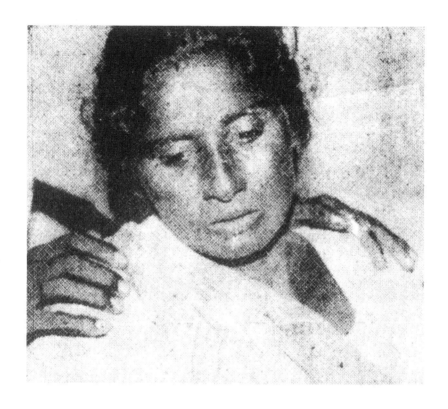

K. Mathumma, a Dalit woman who was stripped, beaten, and paraded
naked in the streets of her village. Her shame was so unbearable that
she attempted suicide after the event.

*"An eerie silence enveloped the village as hordes of policemen, including top
brass, descended on the village on Saturday evening, trying to record the grue-
some incident, coming close on the heels of the killings of scheduled caste
people in Tsunder village in Guntur district."*

India Tribune, September 7, 1991.

DALIT

THE BLACK UNTOUCHABLES
OF INDIA

(AN INTERNATIONAL PROBLEM)

V.T.Rajshekar

Preface to the Third Edition

If the world has at last come to know that (1) India's Dalits (forming 20% of India's 1,000 million population together with another 10%, their blood relations, tribals) are the world's single largest Black population outside Africa; (2) that they constitute the world's most oppressed and persecuted people; (3) that Dalits — the Black Untouchables of India — and Africans have a common origin; (4) that the Indian brand of sanctified racism is more serious than that of South African apartheid; (5) that India is the original home of racism, and (6) that Aryan Brahminism is the father of racism — the credit must go to *Dalit Voice*, India's largest circulated journal among Dalits, and its 15-year crusade, together with Dalit Sahitya Akademy books.

It all began with Clyde Ahmed Winters' guest editorial of Sept. 16, 1985, "African origin of glorious Dalits," which opened the eyes of the entire African-American population, and brought them close to us. The result: Runoko Rashidi came rushing to India and inaugurated the first All-India Dalit Writers Conference at Hyderabad. Then came our editorial, "21st century belongs to Blacks and Africa" (*DV* April 16, 1986). The Dalit Christian delegation to the US led by India's famed Black Bishop, Rev. Azariah (1986) opened up the vast possibilities of fruitful collaboration between the two persecuted peoples (*DV* Edit, March 16, 1987: "Search for cultural roots of Dalits"). The historic collaboration of African-Americans and Indian Dalits began with the publication of our book, *DALIT: The Black Untouchables of India* (1987, Clarity Press,

Atlanta, US), carrying a Foreword by Dr. Y. N. Kly, which for the first time internationalized the Dalit problem and invited the attention of the whole Black world. Ivan van Sertima and Runoko Rashidi's scholarly book, *African Presence in Early Asia* (Transaction Books, Rutgers, 1988) with an article by us on Dalits united the Blacks throughout the world, and forced the World Council of Churches, Geneva, to commit to the Dalit struggle for self-determination.

It was *Dalit Voice* which told the world that Buddha, Prophet Muhammad and Jesus Christ were not white (*DV,* October 16, 1991, p. 6). The credit also goes to *Dalit Voice* for disclosing to the world that "Western whites stole knowledge from Africans" (*DV,* Edit., December 6, 1991). John Tremble of the All-African Peoples Revolutionary Party, Atlanta, US, had earlier detailed the "Historic role played by DV in uniting Africans and Dalits" (*DV,* November 16, 1991, p. 10). It was *Dalit Voice* which gave the warning that "African-American liberation is not possible until Dalits are free" (*DV,* April 1, 1993, p. 14). And it was again *Dalit Voice* which warned the world that "Blacks of the world must unite to fight the Aryan plague" (Ma Tomah Alesha, *Dalit Voice,* November 16, 1992, p. 9). The formation of the International Dalit Support Group in the US, headed by a tireless fighter, Dr. Velu Annamalai, and of the International Human Rights Association of American Minorities (IHRAAM) at the initiative of Dr. Y. N. Kly, author of the book, *International Law and Dalits in India* (1989) made the whole American continent open its eyes to the problem of the Dalits. The list of *Dalit Voice* achievements is too long.

As *DALIT: The Black Untouchables of India* now goes into its Third Edition, I am still unable to travel. My passport is impounded. We here in India are fighting with our backs against the wall. So we issue a special appeal to all Americans, for the rulers of India always surrender to foreign pressure, particularly when it is raised by Americans.

Please, in whatever way you may be able, help our struggle.

V. T. Rajshekar,
1995.

1. Introduction

We are forced to come out with this document because we want to expose a closely guarded secret, kept by the Ruling Class of India which forms a mere 10 per cent of its 800-odd million population living in grinding poverty, misery, squalor and disease. The outside world hardly knows that in India there is a 3,000 year-old problem called Untouchability. And when you come to know the real facts, you will be in tears. If you have tears, shed them now.

Hence, this document is meant for sympathetic foreigners, researchers who are interested in obtaining a correct picture of India–the most ancient civilization in the world but today described as the "sick man of the world."

The Ruling Class of India, comprising bureaucrats, the press, professionals, industrial-landed interests, academic-cultural-religious leaders, priests (the Hindu religious police), the banking-financial sector, and a section of politicians, has successfully given the outside world the impression that Buddha's and Gandhi's land of peace and *Ahimsa* (non-violence) is wedded to the highest and the noblest ideals of truth, toleration, justice, freedom and equality. If anywhere there is a perfect working model of parlimentary democracy in the world, it is in India—the living example of socialism and secularism. India's Ruling Class, as the self-chosen representative of the Buddha and Gandhi, has successfully advertized that it never hesitated to fight against any kind of breach of human rights not only inside the country but also outside. It is in accordance with this image that India observed the International Anti-Apartheid Year (1978–79) with great fanfare. The then Indian Foreign Minister, A.B. Vajpayee, went to the UN General Assembly and delivered an eloquent speech (in Hindi) on the floor of the world forum de-

nouncing the practice of Apartheid in South Africa and other African countries as well as racial discrimination in the USA, UK and other countries. Indian Prime Minister Jawaharlal Nehru, Morarji Desai and Indira Gandhi have always been first in condemning violations of human rights in any part of the world. Since India claims to have given birth to some of the greatest saints and savants, produced the world's holiest of the holy scriptures, tons of godmen, its heart bleeds at the very sight of the slightest injustice in any part of the world. That is why cow slaughter is prohibited in India. Because the cow is a sacred animal. Even the death of an insect is mourned. India means non-violence and non-violence means India.

The outside world, therefore, knows very little about untouchability or India's Black Untouchables. As the late Dr. B.R. Ambedkar, the greatest leader of the Indian Black Untouchables, put it: "Indians have not written about Untouchables for they lack the courage and honesty, and the foreigners have avoided the subject for fear of offending the orthodox Indian masses."[1] Christian missionaries have come out with some studies. *Soviet Communist scholars have completely ignored the Untouchables, fearing the wrath of the Brahmin leadership of the Indian Communist Party.* The Chinese Marxists have also maintained a studied silence on this subject. However one of the best works, *The Untouchables in Contemporary India,*[2] is edited by an American, and has some of the most authoritative articles on Black Untouchables. Any Indian reading the book should be ashamed of the depth of knowledge of foreign scholars. But do the Indian schoioars suffer from any sense of shame? For them, their caste is more important than truth. The Indian "intellectual" is corrupt and caste-oriented. We have no hope in these so-called Indian intellectuals. In fact the Indian intellectual class is the most dangerous class. It is not only hypocritical but dishonest to itself. How can one who is dishonest to himself be honest to others? So we have no hope of any Hindu intellectual coming out with any study on the Black Untouchables. The Indian scholars and social workers do not want to serve the Untouchables because they do not like them. Before anybody wants to serve, she or he has first to like that person. Is it

[1] *Thus Spake Ambedkar*, Vol. II, p. 4.

[2] Ed., J. Michael Mahar, University of Arizona Press, Tucson, Arizona, USA, 1972.

possible to serve a person without liking that person? Because the Hindu scholars and social workers do not like us, they have not served us. Simple. Therefore, we cannot expect any justice from them.

What is the position of the Black Untouchables inside India? Nobody has described the prevailing situation better than the once Deputy Prime Minister of India, Jagjivan Ram, who noted that differences of caste and creed in India have assumed a more terrible form than the racial conflict in the USA against which Martin Luther King fought.

Comparing Untouchability with Apartheid while speaking at a function in Town Hall organized by the Martin Luther King Society to celebrate the anniversary of Mahatma Gandhi's birth, the Defence Minister said that a Brahmin could not be distinguished from a "bhangi" (of the sweeper caste) on the basis of appearances. The same applied to a Muslim and a Hindu, while the contrast between a black and a white was quite obvious. And yet the prejudices in this country are as terrible as in the USA.[1]

Untouchability, therefore, is not a thought of as a racial problem but a mental [or cultural] problem,[2] resulting not so much from Black Untouchables' color as from their cultural and historical economic, social and political circumstances. Jagjivan Ram was referring to the position of India's 80-million Black Untouchables who are called "Scheduled Castes" in India's official documents but popularly known as "*Harijans*" (meaning the children of God), a name given to them by M.K. Gandhi, hailed by the Hindus as the Father of the Nation.[3]

[1]*Statesman*, Oct. 3, 1978. This is an interesting observation since many Black Americans believe that if they assimilated and looked the same as the Anglo-Americanized majority white population, the problem would be solved. This observation in India tells us that even a high degree of biological assimilation will not bring equality, when proceeded by historical circumstances of slavery and apartheid. *Eds.*

[2]It is true, however, that the caste system, and the Black Untouchables' demeaning position in relation to it stemmed from the conquest by the fair-skinned Aryans of the original Black peoples of African genesis. Instituted as a mode of social control over various populations and applied on an ethnic or racial basis, the caste system was originally racist in nature. It also remains true that India's Untouchables are racially African, while physical resemblance to the original fair-skinned Aryans can still be traced in India's Brahmin caste, particularly throughout the "cow-belt" regions most responsible for promoting Brahminic interests.

[3]See p.53, where, placed in its correct historical circumstances, this seemingly attractive appellation is revealed in all its grotesque actuality.

I was talking to a group of university students from Sweden in New Delhi in mid-1982. They were surprised when I gave this booklet to them. Led by their professor, they had been touring India for over a month and they all confessed that they had never heard of India's Black Untouchables or the concept of untouchability practised in India. Wherever they went, they were met by high caste people who told them about the provision in the Indian Constitution "abolishing" untouchability over 30 years ago. So it is all a thing of the past. Like all our foreign visitors, these Swedish tourists also believed this version. Why shouldn't foreigners? Even many affluent Indians living in luxury prefer to believe that untouchability nowhere exists in India. Since untouchability is a mental problem, how can anybody see it? It can't be seen but only felt. The shoe pinches only the wearer. He alone feels the pain. India's Black Untouchables alone feel the pain of untouchability. Not others.

A familiar argument of "educated" Indians is "even the little traces of untouchability left will go once the people get educated." We are sorry, we beg to differ with this. It is the highly "educated" people who are more caste conscious than their illiterate brothers back home in the village. The universities, in addition to the political parties, the news media, etc., are all instruments of the ruling class—the Upper Castes—and are used to indoctrinate the population as a whole with its values, principles and ethics—in India's case, the values, principles and ethics of Hinduism.[1] Each and every Indian is influenced by the dominant Brahminical ideology—even the Black Untouchables, who are the most oppressed by it.

Centuries of indoctrination and miseducation by the Upper Castes have produced and perpetuated literate but politically ignorant generations of Black Untouchable youth. These Black Untouchables have been brainwashed into accepting the commercial lifestyles, attitudes and interests fed to them by the Hindu media. They have become victims of a psychological war aimed at keeping them divided, politically ignorant and disorganized. *The effect has been to make them view the world through the eyes of their oppressors, accepting their oppression and exploitation as the natural order of things. They have taken on their enemy's ideology as their own, and are thus manipulated into working*

[1] The Aryan doctrine of Brahminical superiority may be related to the philosophy of "white superiority" in the US.

in the interest of the enemy, who exploits their labor and robs them of their resources. This ideology tells them to get rich quick. To make money by hook or crook. It tells them to "go up" and "be successful" in society, even while it completely ignores the political and socio-cultural factors that make this impossible.

The aim of Hindu Brahminical ideology is to increase the profits accumulated and controlled by the Upper Castes, to maintain their status quo relationship of domination of the masses of Indian people: Hindus, Black Untouchables, and other minorities alike. In the Brahminical society, universities and colleges reinforce the status quo by turning the youth of the society into miseducated defenders of its reactionary ideology, into unwitting tools of the exploiters of the masses of the people.[1]

Therefore education will bring no relief to India. The problem of caste and untouchability is very aggravated today mainly because of these "educated" people. The problem of caste exists in the mind. It is a kind of Hindu mental disease. Ambedkar called it a mental twist,[2] saying: "Every Hindu believes that to observe caste and untouchability is his dharma—meaning his religious duty. But Hinduism is more than a religious system. It is also an economic system. In slavery, the master at any rate had the responsibility to feed, cloth and house the slave and keep him in good condition lest the market value of the slave should decrease. But in the system of untouchability, the Hindu takes no responsibility for the maintenance of the Untouchable. As an economic system, it permits exploitation without obligation."[3]

Untouchability is observed even by university professors. Election to university student unions is conducted on a caste basis. Untouchables have hardly any admission to the well-guarded precincts of the teaching professions. Therefore untouchability cannot be removed by education alone. Neither can it be abolished by inter-caste marriages nor inter-dining. Caste is a state of mind.

[1] Dalit Voice, Dalit Sahitya Akademy, Bangalor, Jan. 1–15, 1987

[2] This is similar to the way many southern Christians in the U.S. believed that to keep the Blacks in their place (the place they felt God meant for them) was their duty as a true Christian. Eds.

[3] Ambedkar, Can Untouchabiltiy Be Abolished?, pp. 20–21.

This document, therefore, is intended to give a truthful picture of the Indian Black Untouchables to the world. Otherwise, world opinion will continue to presume that India is the land of the most perfect democracy in the world.

In this connection, we would like to point out that the Janata Government headed by Prime Minister Morarji Desai did not allow a foreign firm, Thames Television, to make a TV film on India's Black Untouchables, on the ground that it will give a bad picture of the country to the outside world. The Ruling Class does not mind having something stinking inside its house, but outsiders should not get a smell of it. That is why the filming was banned. Except for one senior Indian journalist, Kuldip Nayar (then with the *Indian Express)* who lodged a strong protest against the double standards of the Government, the press either kept quiet or supported this measure.

2. Who Are the Black Untouchables?

By now, the foreigner will naturally be curious to know who the Black Untouchables are. What are these extraordinary creatures?

"Dalit" is the only name which the Black Untouchables of India have given themselves. Its root word is "Dal", which in Hebrew means broken, crushed. The Black Untouchables, along with the present tribals, form over 30% of India's 800 million population.

The Dalit were the original inhabitants of India and resemble the African in physical features. It is said that India and Africa were one land mass until separated by the ocean. So both the Africans and the Indian Untouchables and tribals had common ancestors. Some portion of these came to found the Indus Valley Civilization.[1] These original inhabitants of India put up a strong fight against the Aryan invaders. However, the latter, working through deceitful means, defeated the innocent but hard-working original inhabitants who had built the world's most ancient civilization in the Indus Valley.

The original inhabitants who fought and were enslaved were kept outside village limits. They became Untouchables (Scheduled Castes). Those who fled to the forests and hills became tribals (Scheduled Tribes).

The invading Aryans were nomads, barbarians, without a civilization. It was they who enslaved women[2] and destroyed the Indus Civilization,

[1]Ivan Van Sertima and Larry Williams, eds, *Great African Thinkers, Vol. 1:Cheikh Anta Diop*, Transaction Books, Rutgers, 1986.

[2]It was the Aryan ideas that gave birth to the notorious *sati* (widow-burning) and *jati* system, according to Runoko Rashidi.

introducing patriarchal gods to the previously matriarchal original peoples. According to Rashidi, *the Aryans enforced the caste system on the Black population (the original inhabitants of India) "with a cold-blooded racist logic with Whites on the top, mixed races in the middle and the mass of the conquered Blacks at the bottom."*[1]

The Black Untouchables were never completely assimilated into the Aryan (Hindu) culture. All over India, they have their own gods, shrines, food habits and cultural identities, despite the fact that they also worship Hindu Gods. The hatred and violence constantly manifested against Black Untouchables to the present time is a clear sign that the war between the invaders and the original sons of the soil continues even today.

[1] Ibid.

3. Population

The total population of India's Black Untouchables is given as 80 million (1971 census), forming about 15 per cent. But this figures does not take into account the vast number of Untouchables who converted to Buddhism, Christianity, Sikhism, etc., but at the same time suffered from the stigma of Untouchability. Leaders of the Untouchables complain that the census of Untouchables is very much suppressed by India's Ruling Class. Census is a matter of first concern in all countries wedded to "democracy" based on adult suffrage. Since politics in India has become a game of numbers, census figures assume high importance. It is the numbers that give added political weight. That is why census figures are deliberately concocted. This complaint is often heard not only from India's Black Untouchables but also from the 61 million Muslims (official figures) forming about 12 per cent of the population. (India has the second largest Muslim population in the world.)

The main reason Black Untouchables suffer via the census is that quite a number register themselves not as "Scheduled Castes"[1] but as Hindus, Hinduism being designated as the country's largest single religion. That being so, census figures cannot be taken as giving a correct picture of India's Black Untouchables or its other persecuted minorities. It is said that India's Untouchables and tribals[2] (officially 7 per cent) together would form a formidable one third of the country's total population.

A more likely estimate of population figures is as follows: Of the 800 million Indians, 20% are Muslims, Christians, Jains, Sikhs, Buddhists,

[1]See Glossary

[2]See Glossary

Parsis and other non-Hindu religious minorities. In effect, the Scheduled Castes/ Scheduled Tribes (30%) and Backward Castes (40%) cannot correctly be numbered within the Hindu fold, as they are not within the Hindu caste system as designated by Hindu scriptures, are not allowed inside any Hindu temple, and are all treated as Untouchables. That leaves just 10% who can correctly be called "Hindus," and of this 10%, about 75% are Shaivites or worshippers of Shiva, the pre-Aryan Indian god, who has nothing to do with any Aryan god, whether Rama or Krishna. Ninety per cent of the so-called Hindus in South India, Northeast India (Bengal, Assam, etc.) and West India (Rajasthan and Saurashtra) are all Shaivites. Worshippers of Rama mostly live in Uttar Pradesh, Haryana and Gujrat and parts of Madhya-Pradesh, mainly the "cowbelt" where the fair-skinned Aryans dwell and it is from these states that all sorts of Hindu Nazi activities are launched.[1]

Since the real population strength of the non-Hindu Indians would upset the balance of power of the Ruling Class, they deliberately suppress the population figures not only of Untouchables but also of tribals, Muslims and Christians. As the Black Untouchables are scattered in all the villages and segregated, they have no capacity to assert their rights. Almost one hundred per cent poverty and illiteracy add to their misery.

[1] See *Dalit Voice*, Dalit Sahitya Akademy, Bangalore, India, May 1–15, 1987.

4. Non-Violence in Practice

Foreigners are often deceived by the concept of Hindu non-violence. There is no greater falsehood than this. The Hindu, so-called preacher of non-violence, belongs to the most violent society on earth. Albert Schweitzer, the great German philosopher, has this to say: that the great command not to kill and not to injure living creatures plays no part in their scriptures as early as the Upanishads, nor concommitantly in their historical relations to others. If the Brahmins of certain circles speak out against animal sacrifice, they do so only because they regard it as unnecessary, not because they are opposed to such slaughter.[1]

It is the blackest lie to say that Hinduism promotes tolerance and non-violence. According to Dr. Romila Thapar, an upper-caste Hindu and head of the history department of India's foremost university, Jawaharlal Nehru University in New Delhi, "The intolerance is implicit in the practice of untouchability, and in the historical texts, there are many references to persecution of Buddhists and Jains by Hindu kings." There is no historical basis for the claim that non-violence and tolerance formed part of the Hindu tradition.[2] Today, we need only refer to the multitude of persecutions, physical attacks and outright massacres promoted by Hindus and carried out against Sikh, Muslim and Black Untouchable populations.[3]

[1] *Indian Thought and its Development*, WICO Publishing House, 33 Ropewalk lane, Rampart Row, Bombay-1, India, 1980.

[2] *Dalit Voice*, Dalit Sahitya Akademy, March 16–31, 1987.

[3] See Annexure.

In this much publicized "Land of Ahimsa" (non-violence), how are India's Black Untouchables treated? Most countries, particularly the feudal-capitalist countries, have their own lowly people who are treated as second-class citizens. But how does Gandhi's India treat its Black Untouchables?

Dr. Ambedkar, the most revolutionary figure of modern India, the greatest Indian since the Buddha, has the following to say: "The Romans had their slaves, the Spartans their helots, the British their villeins, the Americans their Negroes and the Germans their Jews. So the Hindus have their Untouchables. But none of these can be said to have been called upon to face a fate which is worse than the fate of the Untouchables.[1] Slavery, serfdom, villeinage have all vanished. But untouchability still exists and bids fair to last as long as Hinduism. The Untouchable is worse off than a Jew. The sufferings of the Jew are his own creation. Not so are the sufferings of the Black Untouchables. They are the result of a cold, calculating Hinduism which is not less sure in its effect of producing misery than brute force is. The Jew is despised but is not denied opportunities to grow. The Untouchable is not merely despised but is denied all opportunities to rise. Yet nobody seems to take any notice of the Untouchables[2]—much less espouse their cause."[3]

This observation of Ambedkar was made as long ago as 1943. Since then, Israel has been formed in an attempt to solve the problem of the Jews. The American Negro, forming about 15 per cent of the American population, has passed from his non-violent manifestations of 1963 through the crescendo of violent insurrections of 1967. American Black Power has managed to put fear into the heart of the Whites. Besides, the high technology American society will have to search for talent wherever it exists in its eternal pursuit of wealth. Therefore it is compelled to encourage talent and merit, even if it be in the Black. It is not in the interest of a capitalist society in search of peaks of excellence to neglect anybody who helps secure high profit. In this mad race for dollars, it

[1] To be integrated into the Hindu political system under conditions of inequality —whether segregated or superficially assimilated.

[2] Perhaps because of the stigma inherent in the Hindu label of "Untouchables".

[3] Ambedkar, *Mr. Gandhi and the Emancipation of Untouchables*, Bhim Patrika Publication, Jullundur, India, p. 11.

cannot afford to discriminate against the Blacks if the Blacks help to multiply the dollars. But not so in India. Here talent is crushed. Merit is murdered. Many a flower blushes unseen. Caste is the index and merit is seen only among the high-born Brahmins. In such a feudal society, merit becomes the worst casualty. Similarly, the Blacks of South Africa have abandoned the path of non-violence and taken to armed struggle after the Sharpeville massacre. The African National Congress has managed to focus world attention on the struggle of the Blacks. Apartheid today is discussed the world over.

The Palestinians, too, have been shaking the entire world, and have attracted international attention to their problems. Though defeated and driven out of Lebanon (1982), they gained world sympathy.

The World Council of Churches sent a team to investigate the plight of the aborigines of Australia. Christians are also fighting on behalf of Maoris, Burakus, Koreans and Sri Lanka Tamils, but have hardly bothered about India's Black Untouchables. They had reservations about our invitation to send a team to India. They said they could visit only on the invitation of the Indian church authorities. But the Indian Christian Church itself is divided into castes, and Black Untouchable converts are segregated.

Nobody bothers about the Indian Black Untouchables. In sheer number, they exceed the population of the American Negroes, or for that matter, any other struggling, persecuted racial or religious minority group. What can this huge population hope for? Their voice is not only not heard outside India—even inside India, theirs is a cry in the wilderness.

Why does nobody talk about the problems of India's Black Untouchables? The UN General Assembly has had debates on the problem of South African Blacks, Palestinians and other groups who have been denied human rights. But the UNO has not so far cared to spare a thought for the world's gravest problem: the problem of India's Black Untouchables. The point is, nobody has so far complained to the world organization—not the Human Rights Commission, the World Council of Churches nor Amnesty International, not even a representative of the victims. Mother Teresa, the Nobel laureate who operates in India, does not bother about them. There is an all-round conspiracy of silence when it comes to the question of Untouchables.

What is the actual position of the Indian Blacks who are not only Untouchables but unapproachables, unseeables and unthinkables—

the truly invisible men:

"The Untouchables had different names in different parts of the country. They were called outcastes, Untouchables, Pariahs, Pancharmas, Ati-shudras, Avarnas, Antyajas and Namashudras. Their social disabilities were specific and severe and numerous. Their touch, shadow and even voice were deemed by the caste Hindus to be polluting. So they had to step aside at the approach of a caste Hindu. They were forbidden to keep certain domestic animals, to use certain metals for ornament, were obliged to wear a particular type of dress, to eat a particular type of food, to use a particular type of footwear, and were forced to occupy the dirty, dingy and unhygienic outskirts of villages and towns where for habitation they lived in dark, unsanitary and miserable smoky shanties or cottages. The dress of the males consisted of a turban, a staff in the hand, a rough blanket over the shoulder and a piece of loin cloth. The women wore bodices and rough sarees barely reaching the knees.

"These Untouchable Hindus were denied the use of public wells and were condemned to drink any filthy water they could find. Their children were not admitted to schools attended by the caste Hindu children. Though they worshipped the gods of Hindus and observed the same festivals, the Hindu temples were closed to them. Barbers and washermen refused to render them service. Caste Hindus, who fondly threw sugar to ants and reared dogs and other pets and welcome persons of other religions to their houses, refused to give a drop of water to the Untouchables or to show them one iota of sympathy. These Untouchable Hindus were treated by the caste Hindus as sub-humans, less than men, worse than beasts. This picture is still true in villages and small towns. Cities have mostly overcome this state.

"Their miseries did not end at this. As they were illiterate, ill-treated and untouchable, for ages all public services including the police and military forces were closed to them. Naturally they followed hereditary occupations. Some of them plied trades of a lower and degrading order such as street-sweeping, scavanging and shoemaking. Some skinned carcasses and ate carrion, tanned hides and skins, worked in bamboo and cane, and mowed grass. Others who were more fortunate tilled the land as tenants or worked as labourers in the fields; a great number of them subsisted on food or grain given to them as village servants. Thus deprived of social, religious and civil rights, they had no chance of bettering their conditions and so these untouchable 'Hindus' live the life

of a bygone and dead age, dragging on their miserable existence in insufficient accommodation, unsanitary surroundings and social segregation. In short, they were born in debt and perished in debt. They were born Untouchables, they lived as Untouchables and they died as Untouchables."[1]

Even their shadow brings pollution.

The position of the Black Untouchables has hardly changed since 1954 in rural India. The Government of India's own official documents fully support the above statement.

[1]Dhananjay Keer, *Dr. Ambedkar: Life and Mission*, Popular Prakashana, 35-C, Malaviya Marg, Tardeo, Bombay 400 034, India, 1954, pp.1–2.

5. Role of the Press

Why has the world press, which has taken up so many causes, failed to focus on the plight of India's Black Untouchables? This is because the outside press is not aware of the situation in this "land of love and compassion."

Why should we talk of people outside India? Even inside India, quite a large number of people appear to be totally unaware of this situation. In urban India, hardly anybody talks of untouchability. "Where is untouchability now? It is all gone. The Constitution itself has abolished untouchability. It is all over." This is the stock answer a foreigner gets if he tries to question the English-speaking Indian he normally meets. A Japanese journalist attached to a leading daily in Tokyo said that during his ten-day stay in Madras, the country's fourth largest city on the southeastern coast of India, he was not introduced to a single Untouchable, and nobody raised this subject. It was only on coming to Bangalore that he heard of it, and that too because he met us. So it would appear that the Dalit are not only untouchable but unmentionable.

Foreigners touring India normally come into contact with the members of the Ruling Class, which consists of high-caste Hindus. Whether it be a journalist, professional, teacher or student, he or she will invariably belong to a high caste. Those belonging to this Ruling Class normally prefer to remain oblivious to the problem of untouchability, and to make sure it is hidden from the foreign eye. Visitors are never taken to uglier spots (slums) of urban areas, and if by chance they happen to visit villages, the segregation that is a part of village life is never shown. In India it is no longer easy to distinguish a touchable from an Untouchable, especially for foreigners (unlike in the U.S. where the difference between skin colors is more pronounced).

The African Blacks have their own journals to publicize their struggle. They have their own Black literature. The American Negroes and the Palestinians are also equally powerful through their organizations. They have resources. The Palestinians even have an army. A number of books have come out on their problem not only from sympathetic outsiders but from their own writers. Not so with India's Black Untouchables, caused by the Dalits' having accepted, over a longer period, the Hindu integration and assimilation process. They have no organization of their own on a national scale. Not a single press. (They have just made a modest beginning by launching the *Dalit Voice*, an English fortnightly, in 1981, but the Government and the private sector want to starve it to death by denying it advertisement.) Except for the late Dr. Ambedkar, the Black Untouchables have not even had a proper, honest leadership. Parliamentary politics has divided the Black Untouchables' elites between different political parties dominated by Hindus. No intellectual leader has sprung from their ranks following Dr. Ambedkar. How can leadership be built when it is nipped in the very bud? When the Dalit elite aspire to leadership positions as Indians instead of trying to provide the much-needed leadership for their people?

They are not only paupers, but centuries of protein deficiency has made them duds and dullards, physically weak, mentally retarded, socially suppressed, economically impoverished and culturally deprived. Young girls are made prostitutes (Devadasis)[1] blessed by the Hindu religion and gods. The Black Untouchables thus lead lives worse than that of animals. At least dogs are allowed inside houses, but not Untouchables.

Because of the tremendous physical stamina of Negroes, they have produced outstanding athletes, cricketeers, singers and dancers. They have actors, writers and many creative thinkers. Black is Beautiful. So too among other struggling groups.

But not so among the forcibly integrated and assimilated Black Untouchables of India. How can the Black Untouchables produce a writer, thinker, actor or sportsman when the flower is nipped in the very bud? Where is the chance to grow? Ambedkar became a great leader be-

[1]Prostitution of young Black Untouchable girls is sanctioned by Hindu religion, under their appelation Devadasi, meaning maid-servant of God. These girls, coming from impoverished Dalit (Black Untouchable) families, live around Hindu temples, work as dancers and singers, but remain unmarried, to be enjoyed by the priests and other upper caste Hindus. The children born to these "maid-servants of God" are called "Harijans" (children of God), which is the new name that the "Mahatma" gave to our people. In reality, "Harijan" means bastard.

cause of the British (Christian) rule which gave him all-out encouragement. But the British have been replaced by Brahmin rule since 1947, which is systematically suppressing every honest leader to spring up from the Black Untouchables.

When the whole world outside his community is hostile to him, when there is no press to support his cause, none to blow his trumpet, how can the Black Untouchable ever make his voice heard? It is not even heard inside India. How can foreigners know it? So the Indian Untouchables are languishing—unsung, unwept. This is the real picture of the original black inhabitants of India, the rulers of India who founded the world's most ancient civilization (Indisu Civilization) of Harappa and Mohenjadaro.

Why do we say that the problem of Indian Black Untouchables is more serious than that of American Negroes or South African Blacks? The answer is simple: in these countries, the Black man or woman may be employed as a household servant, a wet nurse, a baby-sitter, a cook. Such a servant can cook food for the Whites and serve it too. But not so in India. The Indian Black Untouchable not only cannot enter the house of a Hindu, but even his very sight or shadow is prohibited by the dictates of the Hindu religion. That is why he is not only Untouchable but also unseeable, unapproachable, unshadowable and even unthinkable. When the very sight of an Untouchable brings pollution, we need not speak of anything further.

On the east coast of India there was a serious cyclone some years ago, and several hundreds died. No Hindu came forward to remove the bodies, fearing there might be Untouchables among the dead. Finally Mother Teresa's Christian workers did the job. That is why the Untouchable of India is segregated in every sphere of life: because of upper-caste Hindus' religiously-inspired fear of "pollution".[1] The difference between India's Black Untouchables and American Blacks is that the slavery of the Negroes had the sanction of law, while that of the Untouchable had and still has the sanction of religion. Untouchability is sanctified racism. Many Whites themselves fought against the other Whites to end the practice of slavery. Are any Hindus ready to launch a civil war against the rest of the Hindus for practising untouchability? No, never. Because of this, every Indian village (please note India is a land of villages) is divided into two worlds—the area inhabited by Hindus and the area of

[1] The so-called fear of pollution was, however, no doubt inspired for the material purpose of keeping the Dalits in a position whereby they may be forever exploited. This exploitation of the Dalits serves as the economic and social basis for the position, cooperation and unity of the Upper Castes.

54

Untouchables. No Hindu ever comes anywhere near the ghettoes inhabited by these Wretched of the Earth. This is the case in every Indian village from centuries past, right up to the present day. Every city is segregated[1]—slums have a 90% Black Untouchable population.

[1]Segregation is different from separation in the sense that when one is seg-regated, one is physically separated, but politically, economically and socially under the control of the group that segregates one for exploitative purposes. Separation does not necessarily mean to be physically apart, but always means to be politically, socially and culturally independent or autonomous.

6. The Hindu Caste System

We want to tell our foreign comrades that India is the most complicated country in the world. Even German philosophers were deceived by the Aryan myth [1] *that caused two World Wars.* Even scholars among Indians have not been able to unravel the mystery that is Hinduism.[2] It stands like a colossus, ageless and deathless, not only withstanding every onslaught, but getting fresh props as years pass. The most important and durable institution created by Hinduism—the third largest religion in the world—is the caste system: a four-fold division of Hindu society founded on ethnicity and arranged on the basis of ascending order of reverence and descending degree of contempt.

This hierarchical caste system—a primitive but ingenious Aryan invention—is a fantastic institution if taken seriously as anything other than a technique of oppression. The Eighth Wonder of the World!

[1] Leon Paliakov, *The Aryan Myth*, New American Library, 1974.

[2] This is probably because Hinduism, founded at a time of religious dominance, before the differentiation of political institutions, includes one of mankind's early political philosophies of domination and exploitation subsequently accoutered and mistakenly labeled as only a religion. As such, it served as a system for the integration and inter-gradation of ethnic groups under Aryan rule, with only the latter truly able to understand it for what it was: a socio-psychic method of dominating others. Witnessing the crude attempt of white South Africans to disguise and solidify their rule over the masses of South Africans by creating a color-based hierarchy, itself splintered into countless tribes and ethnicities, we can imagine what the Aryan system might have been like at an early stage, before being normalized, poeticized and dressed with gods.

Rewarded or punished by rebirth in a caste level that fits its deeds and misdeeds in a previous life, the individual soul supposedly endeavors to progress in holiness up the stairs of the caste ladder toward the godhead. The Brahmin, belonging to the ritually purest and highest caste group, stands at the apex of this pyramid of spiritual ascent. The castes are listed below in descending degrees of contempt:

The Brahmin:	5% of the Hindu population
Kshatriya:	4% of the Hindu population
Vaishya:	2% of the Hindu population
Shudra:	45% of the Hindu population

This is the Hindu Pyramid. The fact that the vast majority of the population is at the bottom is a sure sign that it serves to legitimize the rule of the few over the many.

A Hindu's caste is decided on the basis of his birth. Each caste group is divided on the basis of its profession—fixed and permanent—reserving the intellectual pursuits to the Brahmin. Though forming just about five per cent of the total Indian population, Brahmins are the most powerful caste group in India, without whom the country cannot think or act. Brahmins control everything not only as "intellectual" leaders but also as political and Government leaders.

The ruling class of India consists principally of the Brahmins, described as the "*bhoodesatvas*" (Gods of the earth). Dr. Ambedkar says: "That the Brahmins are a governing class is hardly open to question. There are two tests one could apply. First is the sentiment of the people, and second is the control of the administration. I am sure there cannot be a better and more decisive test than these two. As to the first, there cannot be any doubt. Taking the attitude of the people, the person of the Brahmin is sacred.[1]

"As to the second test, take a caste statistics of those occupying the top position in the country. Anybody can get the answer. Of the five Prime Ministers that India has had so far, four were Brahmins: Jawaharlal Nehru, his daughter Indira Gandhi, Morarji Desai and Indira Gandhi again. Most Ministers in every central cabinet are also Brahmins. Every high position is held by them. From birth to death, and even after death, Brahmins are consulted by all the rest of the population."

[1]Ambedkar, *What Congress and Gandhi Have Done to Untouchables*, Thacker and Co., Bombay, 1945, p. 194.

Today's India of exploitation and misery cannot think without the Brahmin, it cannot live without the Brahmin. They have a stranglehold on the life of this country. The entire "sacred scriptures", the *Vedas*, the *Upanishads*, the two *Puranas*, the *Bhagavad Gita*, the *Manu Smirti*, are mostly their creations. As the priestly class manning the millions of temples that dot the length and breadth of India, they are the custodians of God. Nay, its very creators. Therefore, Hindus consider the Brahmin as superior to God.

While the Brahmin stands at the apex of this caste pyramid, the Kshatriya (warrior), Vaishya (trader)—together forming a negligible percentage of the Indian population—also control enormous wealth. These three top caste groups are called *dwijas* (twice-born), and to distinguish them from the *shudras* (once-born), they have the sacred thread. Gandhi belonged to the third caste level (Vaishya) and his sympathies were with the twice-born; ironically, it was a Brahmin who shot him dead.[1] But it is the fourth group, the "shudras", who form the bulk (about 45%) of the Indian population, divided into hundreds of castes and sub-castes. Being a heterogeneous group, it embraces the most powerful land-owning community at the top and other service castes—each alloted a particular duty: barbers, fishermen, shepherds, carpenters and scores of such professions that are necessary to run a village. As India is essentially a land of villages, these caste and sub-caste groups are faithfully following their predestined caste profession. There may be occasional rumblings but because of the powerful Hindu religion which has mesmerized the whole country, for the most part, everybody does his duty without a murmur. The high caste Hindus who own the property and retain most privileges are able to get the work done by the low castes with hardly any violence such as occurs from time to time in South Africa and elsewhere. They do this by replacing violence by an ideology, which is the other word for Hinduism. If Fascists, racists, capitalists, dictators have to use violence to subjugate the ruled, Hindus use the magic mantra of Hinduism with stunning effect. *Hinduism is such a primitive and powerful ideology that it has made the slaves enjoy their slavery.*

[1] V.T. Rajshekar, *Why Godse Killed Gandhi*, Dalit Sahitya Akademy, second revised edition, 1986.

So far we have only touched the Hindus coming under the four-fold division. But the Untouchables do not come under this four-tier caste system and therefore they are said to be outside the caste-fold. At the time of its devising, the Aryans did not admit the original black inhabitants of India into their caste system, or, in other words, into Hinduism. Unlike the Christians, the Aryans did not want these people to enter their religion. Equally, the original peoples refused to join the Hindu caste system, though at one point offered entry to the shudras caste by the Hindus in an attempt to end the 3,000 year hostility between the invading and dominated groups.

Hindu scriptures condemned the original inhabitants of India to be Untouchables (meaning, among other things, enemies), to be kept outside of their system and maintained as slaves. No matter how poorly the upper castes may treat their own shudras, the bottom layer of their caste system, it is important to remember that the Black Untouchables are neither shudras nor Hindus *as defined by Hindu scripture.*

It was the English who invented the suffix "caste", mistakenly applying it to all populations in India, Untouchables included. By so doing, they and the orientalist scholars mistakenly categorized all Indian peoples (other than the religious minorities) as Hindus, (a term invented in fact by the Muslims in the period in which they ruled India.) In reality, the Hindus, consisting of the four castes, comprise a small minority of the population, while the religious minorities and those populations regarded as outside the caste system—the Scheduled Castes (Black Untouchables), Scheduled Tribes (tribals) and Backward Castes[1]—are very large in number.

The error of the English, whether it was or wasn't an intentional tactic to exert control over the whole of India through giving dominance to a minority population, proved advantageous to the Hindus. In order to try to maintain their benefits as a dominant population after the British departed, the Hindus, despite the prohibition of their own scriptures, launched a massive drive to try to "Hinduize" the Untouchables and

[1]Backward Castes too, prohibited from entry to any Hindu temple and treated as untouchables, can be considered as outside the caste system. See "BCs neither shudras nor Hindus", *Dalit Voice*, March 1, 1987. The difficulty in correctly assessing the proportion of the Hindu *shudra* caste within the Indian population lies in the confusions surrounding the categorization of these out-castes as *shudras*, and in their own tendency to identify as Hindus despite all prohibitions against them.

other out-castes, referring to the Untouchables as shudras, ie. as within the fourth tier of the Hindus caste system, and therefore, Hindus. In fact, "Mahatma" Gandhi wanted to create a fifth caste level of Hinduism to accommodate the Untouchables, wherein they would be labeled *pancharmas*.

The advantages to the Hindus of winning the numbers game and appearing to be the majority population are clear: as a majority in a democracy, their preponderance in the various institutions of power is unquestioned; they can reserve unwarranted power over the minorities and frighten them into acquiescence. *By convincing the Black Untouchables that they are shudras, ie. Hindus, they count on them as a "vote bank".* [1] Furthermore, they use them as a social counterforce to subjugate the Muslims, Christians, Sikhs and Buddhists. Today it is the Backward Castes and Scheduled Castes who are used to attack and kill the Muslims. These SCs and BCs are quite unaware that their attacks on Muslims and Sikhs only strengthen the Upper Castes, who have to keep the flame of communalism alive and divert the minds of SCs and BCs from fighting for their own rights and dignities. It is in the interest of the Upper Castes to encourage these "communal riots"; it is the only way to keep their monopoly power over the state and society.

The effort to Hinduize the Black Untouchables has the additional intention of seeing that they do not turn to Islam or Christianity, as they have in fact been doing in large numbers, arguing: "Why should a *harijan* remain a Hindu and suffer all kinds of humiliation if he can easily get respect and recognition by embracing Islam or some other religion?" A Christian or a Muslim can draw water from a well, but if an Untouchable does the same he is either hounded out or lynched. [2] A massive defection of Untouchables from the Hindu ideology into the shelter of Islam as in Tamil Nadu threatens the Hindu power structure.

The assimilation of Untouchables into the bottom tiers of the Hindu caste system has yet another asset for the Brahminical and higher castes: the Hindu religion provides an effective ideology for the suppression of resistance to injustice, having as a central tenet of its propaganda

[1] They are thus "assimilated" when it is to the Hindus' advantage, and segregated when it is not.

[2] A. Antony Dass Gupta, "Why Dalits Prefer Islam, not Christianity," Dalit *Voice*,

the idea that those in the lower castes are poor and suffering because of their misdeeds in the previous birth. And accordingly, as their sufferings are of their own making, and in fact reflect the working out of some inexorable justice, the higher castes are absolved of any responsibility for their condition, and need do nothing to help them even though these ruling castes control the power and resources of the country.

How has this Hindu propaganda affected the Untouchables? Like any victims of a concentrated and pervasive propaganda, they are influenced to believe they are *shudras*, to desire to be *shudras*, even though the Hindu scriptures tell them that they are outside the caste system. The incentive to "reclassify" themselves as *shudras* is great, given their persecution as Untouchables. Those without a name, fame, identity and religion of their own become an easy prey for disintegration and "assimilation"—meaning enslavement under the label of absorption or "integration". *They seek a recognized name to cover their "shame".*[1]

For the most part, their position remains ambiguous. Whether seeing themselves as Untouchables or as shudras, they are under the spell of Hinduism. But as Untouchables, they cannot worship Hindu gods and cannot touch Hindu scriptures. Even in matters of words they are not allowed free choice. They should not use decent, cultured language. They cannot keep decent names for themselves. They are persecuted daily—killed, kicked, burnt, raped because they are not Hindus. Yet, though they are outside the caste system and outside Hindu religion, they form the foundation of the Hindu human pyramid. They carry the weight of the entire Hindu population. The ideology of Hinduism saps their resistance, whether including them as sh*udras* or excluding yet defining and dominating them as avarnas, ie. those outside of the caste system.

Such an hierarchical caste pyramid is something unique, unparalleled in the whole world. Muslims may be divided into Shias and Sunnis, Christians into Catholics and Protestants and other sects, but one sect does not claim superiority over the other. But in Hindu India, it is a graded inequality. The Untouchable is servile, heinous, lowest of the low, condemned to the meanest professions such as scavenging, garbage-cleaning, sweeping, removing dead cattle, shoe-making and generally landless agricultural labor. The Hindu religion prohibits an Untouchable

[1]N.K. Sharma, "BCs neither Shudras nor Hindus,", op. cit.

from owning land. Christianity, Islam or other religions have only "classes", which are mobile. A rich person can become poor and vice-versa. But in Hindu India, a Brahmin cannot become a shudra and a shudra cannot become an Untouchable. There is neither a promotion nor demotion under Hinduism. If under Christianity and Islam, society is mobile, under Hinduism, society is static. Fixed. Caste is decided on the basis of birth, not merit, scholarship or bank balance.

We want to impress our foreign comrades that the founders of Fascism like Nietzsche, Max Mueller, etc., have acknowledged that they borrowed their race theory from the sacred scriptures of the Aryan Brahmins.[1] *Adolf Hitler only implemented the Aryan race theory.* Herein lies the secret of Brahmin admiration for Hitler.[2] Therefore Aryans, the founders of this Fascist theory of "purity of blood", are the real fathers of Fascism. *Hitler's swastika is borrowed from the Brahmins. The RSS symbol is also a swastika.* Fascism may be dead, but Aryan racism is still playing havoc throughout India, and the Black Untouchables, who are racially different from the Aryans, are the worst sufferers of this race hatred. Therefore we want to impress upon our foreign comrades that these Aryans are not merely the enemies of Indian Untouchables and the other non-Aryans, but the enemies of socialism and world peace. Nay. They are the enemies of humanity. Therefore you have a duty to support our struggle against this No. 1 Enemy of the world. By destroying Hinduism, we will not only be saving the Untouchables, but Hindus themselves and Hindu India. Because Hinduism is the deadliest enemy of Hindus and of the modernization and progress of India.

[1] See V.T. Rajshekar, *Who is the Mother of Hitler?*, Dalit Sahitya Akademy, 1984. The American Nazi party, therefore, is an indirect follower of the doctrines of the Hindu Aryans. *Eds.*

[2] Dr. Agehadananda Bharati, "Hindu Scholars, Germany and the Third Reich," *Update*, vol. 6, no. 3, September, 1982.

7. The Ruling Class Controls Government

India's ruling class comprises about 10 per cent of its society—whether it is in the village, the district, the State or the country as a whole. India may have a Parliament, may elect its Prime Minister, but whether it is the member of parliament, the cabinet minister or even the Prime Minister of the country — nobody can go against this ruling class. It is the ruling class that governs India and not its government. The Constitution of India may say anything. Parliament may legislate anything, the Cabinet may decide anything, and the government may finally act on anything. But if the ruling class does not like it, nothing will be implemented. It is the ruling class that decides and not anybody else.[1] That is why all those measures on behalf of Dalits or others, however well-intentioned they may be, will exist only on paper if they are not to the liking of the ruling class. The matter is simple. No government can survive antagonizing the ruling class. Once this very ruling class even removed Indira Gandhi, a former Prime Minister. Please note this ruling class is comprised mainly of Brahmins and other high castes. And it is these high castes who also own the property in India. Therefore "caste" is "class" in India. But let it be noted that this entire ruling class does not include Black Untouchables. How can a servant join the ruling class?

Dr. Ambedkar says: "To take the Brahmins first, historically they have been the most inveterate enemy of the servile classes (shudras and the Untouchables) who together form over 80 per cent of the total Hindu population. If the common man belonging to the service classes in India

[1]V.T. Rajshekar, *Who is ruling India?*, Dalit Sahitya Akademy, 1984.

is today so fallen, so degraded, so devoid of hope and ambition, it is entirely due to the Brahmins and their philosophy. The six cardinal principles of the philosophy of the Brahmins are:

1. graded inequality between the different classes
2. complete disarmament of the Shudras and the Untouchables
3. complete prohibition of the education of the Shudras and the Untouchables
4. ban on the Shudras and Untouchables occupying high places of power and authority
5. ban on the Shudras and the Untouchables acquiring property, and
6. complete subjugation and suppression of women.

"Inequality is the official doctrine of Brahminism ... India is the only country where the intellectual class, namely the Brahmins, not only made education their monopoly, but declared acquisition of education by lower classes a crime punishable by cutting off their tongue or by the pouring of molten lead into the ear of the offender. The Congress politicians complain that the British ruled India by the wholesale disarmament of the Indian people. But they forget that disarmament of the Shudras and the Untouchables was the rule of law promulgated by the Brahmins.

"Indeed, so strongly did the Brahmins believe in the disarmament of the Shudras and the Untouchables that when they revised the law to enable the Brahmins to arm themselves for the protection of their own privileges, they maintained the ban on the Shudras and the Untouchables. If the large majority of the people of India appear today to be thoroughly emasculated, with no manliness, it is the result of the Brahminic policy of wholesale disarmament [and false philosophy of non-violence] to which they have been subjected from untold ages. There is no social evil and no social wrong to which the Brahmin does not give his support. Man's inhumanity to man, such as the feeling of caste, untouchability, unapproachability and unseeability is a religion to him. It would, however be a mistake to suppose that only the wrongs to man are religion to him...For the Brahmin has given his support to the worst wrongs that women have suffered from in any part of the world...Widows were not allowed to re-marry. The Brahmins upheld the doctrine. Girls were requested to be married before 8 and the husband had the right to consumate the marriage at any time thereafter; whether

she had reached puberty or not did not matter. The Brahmin Aryan gave the doctrine his strongest support. The record of the Brahmin as lawgivers for the Shudras, for the Untouchables and for women is the blackest, in comparison with the record of the intellectual classes in other parts of the world. For no intellectual class has prostituted its intelligence to invent a philosophy solely for the purpose of keeping its uneducated countrymen in a perpetual state of ignorance and poverty as the Brahmins have done in India. Every Brahmin today believes this philosophy of Brahminism propounded by his forefathers. He is an alien element in the larger Hindu society. The Brahmin vis a vis Shudras and Untouchables is as foreign as the German is to the French, as the Jew is to the Gentile or the White is to the Negro. There s a real gulf between him and the lower classes of Shudras and the Untouchables. He is not only alien to them, but also hostile to them. In his relationship with them, there is no room for conscience and there is no call for justice."[1]

Rural India has changed very little from the time this was written. It is because the Hindu does not believe in change. Change is, however, very much there. But only in form. The Hindu does not believe in any change in content. An American-educated Hindu nuclear scientist may be modern in his dress and food habits, but his thinking will likely be ancient. He has outwardly changed but his value system stays put.

When there is so much of a gulf between the ruling class and the rest, between the touchable Hindus and the Untouchables, one can very well imagine the chasm between the ruling class and the Untouchables. it is like the North Pole and the South Pole. "In other countries, there is, at the most, a hyphen between the two. A hyphen is only separation, but a bar is a severance, with interests and sympathies completely divided. In other countries, there is a continuous replenishment of the governing class... In India, the governing class is a closed corporation in which nobody not born in it is admitted."[2]

That is why India has become a stagnant society. A sick society. So why does Hinduism survive the ages?

[1]B.R. Ambedkar, *What Congress and Gandhi Have Done to Untouchables*, pp. 203–205.

[2]Ibid., p. 220.

8. The Wonder of the Hindu Religion

Foreign comrades may wonder why India is like this. Why are Indians behaving in this strange way? Why is it decaying? The answer to the question is to be found in the Hindu religion, which has conditioned the Hindu mind. "Hinduism preaches separation instead of union. To be a Hindu means not to mix, to be separate in every thing...the real genius of Hinduism is to divide...for caste is another name for separation and untouchability typifies the extremest form of separation of community from community from community."[1]

That is why Hindu India is not a nation and can never be a nation. It is a group of nationalities. Each caste or subcaste is a separate nation. Nay. It is a prison house of warring nationalities. Language has further divided the people. "Factually, the Hindus and the Untouchables are divided by a fence made of barbed wire."[2] Democracy, socialism and secularism are foreign to Indian soil. In any other country, the daily problem may be that the weather is unpredictable; in India the problem is that the people are unpredictable. Each caste, sequestered onto itself, becomes an enigma to the others.

[1]Ibid., p. 179. It could be said that the real genius of Hinduism is to divide for the purpose of exploiting others, and that caste is another name for segregation and exploitation, with untouchability typifying the extremest form of segregation of one's community from the other communities for the purpose of its exploitation. The only community which does not receive any benefit is the one on the bottom, since it has no lower community to segregate. In India, the community on the bottom includes the vast majority of the Indian population.

[2]Ibid., p. 179.

Indian Express Washington correspondent, T.V. Parasuram, in a dispatch published in his English daily (Bangalore edition, Feb. 17, 1982), reports a controversy going on in the columns of the *New York Times* about a three-year-old study of the British High Commission in India, saying: "In Hinduism there is no good or evil as is the case of dualistic religions such as Christianity, Judaism or Islam. A natural concomitant of the absence of sin is the lack of ideals about truth. There is little place in the Hindu ethos for truthfulness, social service or moral courage. The preoccupation is with the internal development of the individual. While in every country, politics is a career, in India it is a business." Purasuram, himself a Brahmin, then quotes the *New York Times*, saying: "A number of Indian social scientists have noted that individual rather than collective redemption lies at the heart of Hindu practice and that as a result social responsibility is generally narrowly defined."

Foreign scholars and also unbiased Indian experts now agree that Hinduism is the cause of India's corruption, its poverty and its myriad ills. Albert Schweitzer observed: "The Hindu religion believes in world and life negation. The Hindu does not take an interest in the world, but regards man's life on earth either merely as a stage-play in which it is his duty to participate, or only as a puzzling pilgrimage through the land of Time to his home in Eternity."[1] As Dr. Ambedkar has pointed out, "From the viewpoint of the annihilation of caste, the struggle of the saints did not have any effect on society. Their struggle had a very unhealthy effect on the Depressed Classes. It provides the Brahmins with an excuse to silence them by telling them that they would be respected if they also attained the status of Chokhamela (Sainthood)."

To the Black Untouchables who have to bear the brunt of this burden,[2] Dr. Ambedkar advises: "The sooner you remove the foolish belief that your miseries were pre-ordained the better. The thought that your poverty is an inevitability and is inborn and inseparable, is entirely erroneous. Abandon this line of thought of considering yourselves to be slaves."[3]

[1] *Indian Thought and Its Development*, WILCO Publishing House, 1980, p. 2.

[2] Speech at Nasik, Jan., 1928.

[3] Address at the Sir Gowasji Jehangir Hall, Bombay, Oct. 18, 1932.

The editor of India's prestigious English daily, *Statesman*, also agrees that Hinduism is killing India, implying that double-think, double-standards, double-cross is a way of life, with one set of rules to the high-born and another to the lowly creatures. "Basically the Hindu mind is unable to see anything fundementally wrong about it."[1]

Therefore, our considered opinion is that if India is to live, Hinduism must die.

[1] *Statesman*, Dec. 17, 1981.

9. A Probable Solution

It was the British who for the first time united the warring Indians under one government, and the moment they left in 1947, the Indian population was divided into India and Pakistan. The Naga tribes got a separate state. Many more separatist demands are growing. The Sikhs are demanding a separate nation of Khalistan. India will be divided and sub-divided again, for the Hindu religion divides and does not unite the Indians. There is no Indian in India. His loyalty is first to his caste if not sub-caste, rather than to the nation. Any visitor to India can make this out in no time. Even Hindus in the USA observe caste rules, untouch-ability and segregation. The Hindu carries his caste wherever he goes. In the U.S., the Black Americans are no doubt victims of his Aryan pretenses.

Upon the departure of the British in 1947, when the Muslims were accorded Pakistan and the Hindus India, a special system of "reserva-tions" (or affirmative action quotas assuring them jobs within the civil service) was instituted to be of benefit to Black Untouchables. During the negotiations, Dr. Ambedkar, the leader of the Black Untouchables, pressed for a "separate electorate" for Black Untouchables. However, the Hindu ruling classes responded with Mahatma Gandhi's "fast unto death", and threatened a wholesale massacre of Black Untouchables if he did not withdraw his demand. Faced with such a threat, Dr. Ambedkar

was forced to withdraw the demand for a separate electorate, or separate state, and agreed to what appeared to be an improvement in conditions for Black Untouchables: the Hindu "gift" of quotas.[1]

Quotas or no, the solution to the Dalit quest for equality does not lie in their final absorption into Hinduism. Therefore the Black Untouchables of India are fighting for a homeland, *Dalitastan*. The need for a separate homeland or state for Black Untouchables is clear. They were forced to come out with this demand when inhuman tortures and the burning of Untouchables reached a climax in the State of Maharashtra in the middle of 1978. The government itself had admitted that the atrocities against Untouchables had been mounting year after year. A Hindu fascist force called the RSS has managed to take control of the ruling

[1]Sentiment with regard to these quotas among Black Untouchables is mixed. On the one hand it is argued that quotas are based on the recognition that the Black Untouchables are a separate entity in India, and the posts reserved for them are their legitimate share in the state and society, paid for in their blood. As such, they are not based on "poverty" or "backwardness" or "reverse discrimination" as is commonly alleged by the upper castes. Miss Kavita Kumari, *Dalit Voice*, Dalit Sahitya Akademy, Feb. 1–15, 1987, writes: "Reservations are not donations from any one. We paid with blood for them. [Our leader Dr. Ambedkar and his followers] sacrificed many lives to secure their national rights called [quotas] and they are ready to sacrifice more lives to protect their rights. In 1981, the Black Untouchables in Gujarat formed squads and died to defend their rights (quotas) in the face of upper caste violence, killings and atrocities in their 'anti-quota war'. Sensing a caste war throughout the country if they touch our rights, the Indian Parliament and the state legislature passed unanimous resolutions reiterating and reaffirming the policy of quota jobs for Black Untouchables. It is not the votes and the vote-banks of Untouchables that made the rulers swallow their pride. In 1984 when the upper castes resorted to violence against the Black Untouchables in the name of anti-quotas, the Black Untouchables, who are well represented in the lower ranks of the police, revolted. They repaid the upper castes in their own coin by burning the newspapers leading the anti-quota war. That made the upper castes talk of 'law and order.'"

On the other hand, as A.M. Abraham Ayrookuzhiel notes in "Mischievous attempt to detain Black Untouchables in Slavery," *Dalit Voice*, March 16–31, 1987, it can be argued that quotas have been a trap for Black Untouchables, forcing them to declare themselves as Hindus in order to be eligible for quotas, thus forcing them to integrate into the Hindu civilization and religion, despite the fact that it is Hinduism that has created and maintains the concept and living conditions of untouchability that oppresses them. Quotas are simply an economic lever to bring the Black Untouchables into the Hindu cultural fold and to maintain them there in apathy and slavery.

Janata Party (1978) and the government, and this became the reason for the increasing number of atrocities against Untouchables and Muslims since early 1977. The killings of Untouchables that enveloped almost the whole State of Maharashtra were caused by the simple issue of renaming a university after Dr. Ambedkar, the greatest Indian since the Buddha. The Hindus who form the majority[1] in every village, were waiting for an opportunity to pounce on the Untouchables, and Hindu prejudice poured out in full fury as never before. They pounced on the Untouchables like mad dogs. The "Marathwada massacre", both in intensity and total damage, will exceed all other previous atrocities against Untouchables. Never before has the country witnessed such a wholesale war on the Untouchables. The real cause, therefore, was not the renaming of a university, but the constitutional safeguards or affirmative action rights given to the Untouchables. Even these little crumbs of bread, bones and skin thrown at those waiting outside the grand feast in the Hindu household led to great heart-burning and jealousy.

The "Marathwada massacre" has confirmed the fears of Dr. Ambedkar that majority rule (democracy) in India means the rule of the majority (dominant) community, which in turn means Brahmin rule.[2] The Marathwada caste war was followed by the "Gujarat caste war" on Untouchables. And such wars have become a daily feature in the life of Untouchables. The Hindus who are so very concerned about cow slaughter are not bothered about the slaughter of human beings.[3]

Hindus control the government, the policy, the judiciary, press and all else, including the military. Whenever there is any violence against Untouchables, the whole world comes down on them. The Marathwada massacre of Untouchables and the Gujarat caste war have proved this once again. As described by the press, it is organized violence against a friendless, helpless social leper. Untouchables are neither allowed to live or to die as human beings. *Because if they are killed wholesale, the*

[1] The ambiguous make-up of this so-called majority has been described earlier.

[2] The same as majority rule (democracy) in the U.S. means Anglo-American rule. It is unabashedly admitted by most North American newspapers and TV that Jesse Jackson cannot become president of the U.S. because he is not white. *Eds.*

[3] For details, please read report No. 26, The Untouchables of India, 1982 reprint,

Hindus will be deprived of free servants, slaves. So the Untouchables hover between life and death. They are a living dead.

The Blacks of India must reject the whole cultural system of Hinduism. Their willingness to do so is illustrated by mass conversions of Black Untouchables to the religion of Islam. As A. Antony Doss Gupta notes: "The Untouchables know perfectly well that they will lose privileges, concessions, grants and subsidies on their conversion to Islam. Yet they are willing to embrace Islam. What is the motive?

a) Social inequality. Social inequality is the primary reason for the Untouchables losing faith in Hinduism. Even after 40 years of India's "independence", they are not permitted to walk on public roads with their chappals on, to drink tea in village tea shops in common tumblers, to ride their own cycles or sit on their own cart when passing through Hindu areas . . . The Untouchables feel totally insecure in spite of all the assurances written in the Constitution of India.

b) Sexual abuse. The upper castes hate the Untouchables from the bottom of their hearts, but not their young daughters, wives and widows. Dishonoring Black women is not uncommon, and the majority of clashes are on this account. Black Untouchables know for certain that it they embrace Islam, the lives of their family members, their property and the honor of their women will be well protected. Nobody ever heard of a Muslim woman being raped or molested or dishonored. Black Untouchable women want exactly this. They hope to get this protection only by embracing Islam, rather than the Christianity which in India is nothing but a modified Hinduism, as it still observes the caste system."[1]

What, then, is Hindu India offering the Black Untouchables when it offers them quotas, if in order to get quotas, the Blacks must accept to become a part of a civilization which by its very structure and philosophy views them as lowest of the low? Does the integration of Blacks in India means the acceptance of crumbs and token concessions and protections on paper in exchange for belonging in the fold of a culture which despises you?

[1]A. Anthony Dass Gupta, *op. cit.*.

Do you know this?

Democracy in general, and the assimilation of Untouchables in particular can never work in Hindu India. "To put the matter in general terms, Hinduism and social union are incompatible. By its very genius, Hinduism believes in the social separation, which is another name for social disunity and even creates social separation. If Hindus wish to be one, they will have to discard Hinduism. They cannot be one without violating Hinduism. Hinduism is the greatest obstacle to Hindu [and Indian] unity. Hinduism cannot create that longing to belong which is the basis of all social unity. On the contrary, Hinduism creates an eagerness to separate."[1]

That is why millions of Blacks, disgusted with Hinduism, have become Muslims and Christians. *The 1981 mass conversion of Untouchables to Islam in South India is an historic event that unnerved the orthodox Hindus.* But events since then proved that Hindus will never learn. They have neither learned anything nor forgotten anything. This so-called "great Hindu civilization", about which the Brahmins brag so much, has over the past 6,000 years (some Brahmins say it is still older) produced millions of Untouchables, some millions of tribals, some millions of criminal tribes, vagrants, beggars, thieves, thugs, child laborers and prostitutes (*Devadasis*)—all sanctioned by its religion and god.

"What can one say of this civilization? With a civilization which has produced these results, there must be something very fundamentally wrong—[one must wonder] whether they could be called civilized with this kind of results produced by their civilization."[2]

The Black Untouchables of India should therefore see no advantage in trying to further their own interests within the context of such a society. Dr. Ambedkar declared that *he would never die a Hindu.* Listen to what the Black Untouchable poets proclaim, to V.L. Kalekar of Maharastra: "I reject your culture. I reject your [Hindu] tradition." For them, the call for a Dalit (Black Untouchable) culture entails a rejection of the whole Hindu cultural system. This is symbolic of change and revolution.[3]

[1]Ambedkar, *What Congress & Gandhi Have Done to Untouchables*, p. 179. This eagerness to separate, most particularly among the upper castes, is actually an eagerness to segregate viz a viz the lower castes and outcastes. On the other hand, the urge to separate thus generated among the Dalit is the desire to secure both political and socio-economic independence.

[2]*Thus Spake Ambedkar*, Vol. 2, p. 96.

[3]As quoted from A.M. Abraham Ayookuzhiel, *op. cit.*.

The right of Black Untouchables to quota jobs should not be tied to their declaring themselves to be Hindus. Blacks should have the freedom to create a new cultural system which can promote and sustain their struggle for justice and human dignity. While preserving the right to quotas, they should have the cultural freedom to transform their society, to create and live in a society where the notions of Black untouchability and caste discrimination are non-existent. The present arrangement of tying their economic rights to their participation in the old cultural system is a cruel denial of their full range of human rights.

It is for these many reasons that the Black Untouchables of India are fighting for a homeland, Dalitastan.

10. The Indian Marxists

The "Marathwada caste war" on Untouchables that raged for a full 10 days and enveloped a region inhabited by 10 million people, in which hundreds of Untouchables suffered, and the "Gujarat caste war" that followed, have once and for all exposed the Indian Left parties both in theory and practice. *The leadership of these parties is in the hands of high caste Hindus, particularly Brahmins. Therefore it deliberately does not take note of the social problems arising out of the caste system.* The problem of untouchability, caste exploitation, is never discussed by these parties, which blindly interpret the Marxian dialectics without suitably modifying the theory and tactics to suit the peculiar Indian conditions as Mao did in China. "Classes" are economic. There is no doubt about this. But social, political, religious and historical factors are equally important in determining the form of these "classes". *Engels, in a letter to Joseph Bloch of September 21–22, 1890, said "if somebody twists this into saying that the economic factor is the only determining one, he transforms that proposition into a meaningless, abstract, absurd phrase."* The Indian Marxists speak only of "class struggle"[1] and not of "caste struggle," or the need for national liberation.

Since "class"–consciousness may exist only in urban areas, that too among industrial labor, Marxist influence could hardly penetrate the rural areas—let alone the Black Untouchables, who have been totally

[1]V.T. Rajshekar, *The Dilemma of Class and Caste in India*, Dalit Sahitya Akademy, 1986.

left out of the Left Movement. What is the use of a Marxist party that does not inspire the socially lowest and the economically poorest—the born proletariat?

The high caste Hindu Left leadership ignored the problem of Untouchables because it found the issue inconvenient. The very fact that in the Marathwada massacre and Gujarat caste war, no left party has sided with the Untouchables, verifies the total disenchantment of the Untouchables with the Indian Marxists. They don't want to admit that as long as caste remains, it will pose the biggest danger to class struggle. And if they do know that caste is hindering "class struggle", then they are consciously getting in the way of revolution. The Untouchables, therefore, rightly feel that the Marxists in India are counter-revolutionaries. It is caste that brings unity in Hindu India and not class. Every election is fought on a caste basis, and even Marxists follow this. According to Ambedkar, the problem of untouchability is really a matter of caste struggle. It is a struggle between caste Hindus and Untouchables. In this struggle against Hindus, we want to seek the support of tribals, Muslims, Christians and Sikhs. The Other Backward Castes (OBCs) are welcome to join us.

Gail Omvedt, a noted American social scientist who has made a scientific study of the Marathwada massacre, says: "Having denied the reality of caste except as an illusory part of the superstructure, it is no wonder that communists (in India) have never initiated and led a democratic movement aimed specifically at the abolition of caste discrimination."

Having been let down by Hindus including the so-called Marxists, the Untouchables are desperate. If India had a revolution, Dalit revolutionaries would have been the greatest beneficiaries. But alas the Brahmin leadership of the Marxist parties has blocked the Indian revolution and betrayed the Dalits.

[1]As it is race that brings unity in the U.S.. Eds.

[2]Frontier, p. 40, Sept. 30, 1978. Frontier is an English weekly journal of Marxist-Leninists published in Calcutta.

11. Let Down By Everybody

In this way, the Black Untouchables have been let down not only by the ruling class and the government, but even by the Left parties. The Constitution of India has abolished untouchability—on paper. Nonetheless, in the ensuing 30 years, untouchability has continued with full fury. That is because the Constitution abolished only untouchability, not the caste system itself. As long as the caste system as a whole is not abolished, untouchability alone cannot be removed. The ruling class knows it and that is why it has no plans to abolish the caste system. Any dent on caste means sure death to Hinduism. Will a Hindu stab Hinduism in order to save India?

India's ruling class does not want to abolish untouchability because it provides a lot of socio-economic benefits, and more than anything else, the bulk votes of the Untouchables to the ruling class. They are its "vote bank", which gives interest-free loans.

The Black Untouchables may be large in number, but they are poor, weak, unorganized, and terror-stricken. Caste and sub-castes have divided them also. They have neither political, economic nor social status, and are almost 100 per cent illiterate. They are desperate. There are three types of strength: (1) manpower, (2) financial power, and (3) mental power. Financially, they have no power. With regard to mental strength, the situation is deplorable. How can a set of people accustomed to daily insults get mental strength? As for manpower, their sheer number may make some conclude they have this strength. But they are divided into hundreds of castes and sub-castes and torn into different

languages. Political parties have further divided them. So theirs is a pathetic story. Darkness stares at their faces. They are in all-round gloom. In such a powerless state, how can they organize any opposition against a heartless Hindu society?

As already stated, Hindus by themselves will not abolish untouchability because it has done them so much good. It has given them many advantages. Without the destruction of the Hindu religion, untouchability cannot go. But are they ready for this impossible job? No. Never. The very thought of shaking off Hinduism will bring greater retaliatory disaster to Untouchables. Therefore they are made to die a slow death inside this gas chamber of Hinduism. Nay. They are themselves getting Hinduized, in a manner similar to the way some Blacks in the U.S. have become Anglo-Saxonized. The belief in the theory of fate, destiny and other rituals has bound them fast to the Hindu religion. So much so, the slaves have started enjoying the slavery. There is hardly any protest. Not even a whimper.

12. Appeal to the United Nations Organization

Hence, in all humility and in utter helplessness, the conscious lot among Black Untouchables are forced to demand a separate homeland. Not because they want to be separated but because the Hindu Aryans have no mind to live in peace with Blacks. Hindus are massacring Untouchables because they feel that we are a separate nation. The Aryans are right in saying that we are a separate nation. Dr. Ambedkar also says the same. He says that the Untouchables are not a sub-head or a subsection of the Hindus, but "they are a separate and a distinct element in the national life of India, as separate and distinct as the Muslims; and like the Muslims of India, the Untouchables are entitled to separate political rights as against the Hindus of India."[1] Ambedkar is right in saying that *"Hindus who are their traditional enemies could not be trusted... It was therefore absolutely necessary that there should be a political partition between the Untouchables and the Hindus."*[2]

[1] *Thus Spake Ambedkar*, Vol. III, Ambedkar Sahitya Prakashana, Bangalore, p. 121.

[2] Ibid., p. 122. Read: Barbara Joshi, ed., *Untouchable: Voices of Dalit Liberation Movement*, Minority Rights Group Publication, 171 First Avenue, Atlantic Highlands, N.J. 07716, 1986.

Our foreign comrades will be fully convinced of this argument if only they go through the Government of India documents prepared by Hindu officials themselves. The yearly document of the Scheduled Caste Commissioner to the Government of India is enough to prove that Hindus and Untouchables are two different nations and behave like that. The report of the Scheduled Caste Commissioner has volumes to say about the unending Hindu violence against Untouchables. And the different SC Commissioners were all Hindus. The document of the Minority Rights Group, London, fully endorses our argument.

There is much propaganda by Hindu journalists and writers to the effect that Gandhi has done so much for Untouchables, toward the eradication of untouchability. We are not questioning Gandhi. Who are we to question the Hindu claims? He may be great to the Hindus for helping them. Because he helped them so much, the Brahmins conferred the Mahatma-hood and the "Father of the Nation" title on him. But as far as the Untouchables are concerned, nobody can better answer on their behalf than Dr. Ambedkar: Gandhi "remained the determined opponent of the claims of Untouchables . . . I want you to bear in mind that Mr. Gandhi is our greatest opponent. I do not like to use the word enemy, though there is enough justification for it."[1]

We would have been happy if only he had been our honest enemy. But alas, in spite of being a butt-licker of the Brahmins, he was finally shot dead, not by an Untouchable or a Muslim or a Christian but by a Brahmin.

Untouchables feel that under a democracy (Hindus hail India as the greatest working democracy of the world), the people have a right to demand what they want. *Since India has proclaimed itself to the world as "the only perfectly working democratic country in the world," it must concede to the demand of the Untouchables for a separate homeland.* But the Untouchables know fully well that no man with property and privileges will surrender them voluntarily.

And in this endeavor for a separate homeland, the Black Untouchables of India—the single largest persecuted minority in the world—want to approach the United Nations Organization, its Human Rights Commission, the World Court, and anybody who has a soft corner in her or his heart. *We want to make it clear that any section of the population*

[1]*Ibid*, p. 124.

in any given country has the right to go to the UNO if it feels aggrieved.
The Blacks of Africa, the Negroes of America', the Palestinians and other struggling groups, Burakus, persecuted minorities the world over like the Sri Lanka Tamils—whose problems all put together would pale into insignificance before those of the Indian Black Untouchables—may please lend a sympathetic hand in our fight for survival, shed a tear or two over the living corpses. The World Council of Churches, the Pope, the Arabs and the Muslim world, please note. Do you know that India once belonged to the Untouchables and tribals? And today the very owners of India—the original inhabitants—are being butchered?

Dr. Ambedkar says: "The Hindus practice injustice and tyranny against Untouchables only because they are helpless. From this discussion two facts are clear. Firstly, Untouchables cannot face social and religious persecution so long as they remain weak and divided. Secondly, they do not possess enough strength to face the tyranny. With these two conclusions, the third one automatically follows. That is: the strength required to face the tyranny needs to be procured from outside."[1]

The Untouchables appreciate that there are any number of Whites who are sympathetic to the urges of the Blacks and Negroes, just as there are some Hindus inside India sympathetic to the plight of the Black Untouchables. Such of them are requested to spare a thought for the world's most heinous crime which is being perpetrated inside India in the name of religion and god.

The Black Untouchables urge foreign journalists and other media people and writers to take up the cause of these "Wretched of the Earth," and focus international attention on this cleverly concealed part of Indian life. Expose this naked truth to the whole world. Let the mask of Hindu humbug be torn, and its ugly face of hypocrisy paraded all over the world.

We also appeal to the Marxists in China, Russia and other countries to clear the cobwebs from the minds of the Indian Communists, so that they will see that the Untouchables and tribals form the most revolutionary segment of the Indian population, and that India can never have a

[1] L.R. Balley, *Untouchability, will it ever vanish?*, Brhim Patrika Publications, 1981, p. 29. Also read: L.R. Balley, *An open letter to the people of the world— Violation of human rights in India*, Buddhist Publishing House, Jallandhar, Punjar 144 003, India, 1986.

revolution without them. Sadly, such an appeal is bound to fall on deaf ears. Marxists of the world should directly support the struggle of the Untouchables. The dictatorship of the proletariat in India will take the shape of the dictatorship of the Dalits.

Communists of the outside world, please note that the Indian Untouchables are like dynamite. Their body is like steel, and their mind a volcano. They are an explosive commodity. They would burn the whole land, once ignited. Somebody has to light the dynamite, and it will explode, and when it explodes, the whole world will benefit. The Untouchables and tribals will assure that the Indian Revolution of their dreams will surpass even the Chinese Revolution.

We long for Revolution, we yearn for Revolution, we pine for Revolution. And we are prepared to die for Revolution. Let hundreds of Untouchables die so that India may live in peace. This country is ours. Therefore we love India more than the Aryan invaders. We want to liberate India from the tyranny of foreigners and this most gory form of Apartheid.

Friends of the persecuted minorities the world over, please support us to usher in India's Revolution.

Blacks as a
Global Community[1]

Runoko Rashidi

In 1987, after meticulous DNA analysis, an elite group of scientists based at Oxford University noted: "it seems likely that modern man emerged in Africa and... that subsequently a founder population left Africa and spread throughout Europe, Asia and the Americas."[2] As the direct result of these migrations, African people came to populate the rest of the world. If it were not for these early migrations, humanity would have remained physically Black, and the rest of the world outside the African continent would have been devoid of human life. Therefore, the earliest modern humans *(homo sapiens)* in Asia were of African birth. The African presence in ancient Asia is demonstrated by the history of Black populations that have inhabited the Asian land mass within the span of modern humanity.

Traces of African people have been found in the prehistoric and historic periods throughout east Asia. A Japanese proverb states: "For a Samurai to be brave, he must have a bit of Black blood." [3]

[1] Reprinted from "Blacks as a global community: Dalits are world's most oppressed people," *Dalit Voice*, August 16-31, 1994.

[2] J.E. Wainscoat, "Out of the Garden of Eden, *Nature*,, January 1, 1987, p. 13.

[3] Cheikh Anta Diop, *The African Origin of Civilization: Myth or Reality?* trans. and ed., Mercer Cook, Lawrence Hill, New York, 1974, p. 281.

In China, an Africoid presence is visible from remote antiquity through the major historical periods. The Shang, for example, China's first dynasts, had a prominent Black foundation, to the extent that the conquering Chou described them as having "black and oily skin." The famous Chinese sage, Lao-Tze, 600 B.C.E. (before the common era), was "black in complexion." Lao-Tze was described as "marvellous and beautiful as Jasper."

Evidence of the presence of African people in ancient Southwest Asia is documented in the works of Homer (c.800 B.C.E.). Homer describes the Blacks, or Ethiopians, as "dwelling at the ends of the earth, towards the setting and rising sun." The Greek historian Ephorus (c. 375 B.C.E.) agreed with Homer and wrote that "the Ethiopians were considered as occupying all the south coasts of both Asia and Africa... divided by the Red Sea into Eastern and Western Asiatic and African."

Phoenicia was the name given by the Greeks in the first mellennium B.C.E. to the coastal provinces of modern Lebanon and northern Palestine, although occasionally the term seems to have been applied to the entire Mediterranean seaboard from Syria to Palestine. Phoenicia was not considered a nation in the strict sense of the word, but rather as a chain of coastal cities, of which the most important were Sidon, Byblos, Tyre and Ras Shamra. To the Greeks, the term Phoenician, from the root phoenix, had connotations of the color red, and it is likely that the name was derived from the physical appearance of the people themselves.

The Phoenicians were a coastal branch of the Canaanites who, according to Biblical traditions, were the brothers of Kush (Ethiopia) and Mizraim (Egypt) — members of the Hamite, or Kamite, ethnic family. The Bible says that the Canaanites, Ethiopians and Egyptians were all Blacks and of Nile Valley origin. It was among the Canaanites that one of the most meaningful inventions in human history evolved — the alphabet.

The Reverend Rufus Perry's pamphlet, *The Cushite, Or, The Children of Ham (The Negro Race) As Seen by the Ancient Historians and Poets,* was published in 1887. The Arabian peninsula, first inhabited more than 8,000 years ago, was early populated by Blacks. Once dominant over the entire peninsula, the African presence in early Asia is most clearly traceable through the Sabeans. The Sabeans were the first Arabians to step firmly within the realm of civilisation. The southwestern corner of the peninsula was their early home. This area,

which was known to the Romans as Arabia Felix, today is called Yemen. In antiquity, this region gave rise to a high degree of civilisation because of the growth of frankincense and myrrh, its close proximity to the sea, and consequently its importance in the trade routes between India and the Horn of Africa. The Sabeans have even been called "the Phoenicians of the Southern seas." Frankincense was used lavishly in cremation services and, in Kmt, for embalming. Myrrh was the foundation of many cosmetics and perfumes, and it was also used medicinally.

Before the advent of Islam, southern Arabia already possessed the sacred Kaaba sanctuary, with its black stone, at Makkah. Diop claimed that "The Kaaba was reputed to have been constructed by Ishmael, son of Abraham and Hagar the Egyptian (a Negro woman), historical ancestor of Mohammed, according to all Arab historians." "In Egypt, he (Abraham) had married a Negro woman, Hagar, mother of Ishmael, the Biblical ancestor of the second Semitic branch, the Arabs. Ishmael was said to be the historical ancestor of Mohammed."

The city of Makkah was considered a holy place and the destination of pilgrims long before Prophet Muhammad. Muhammad himself, who united the whole of Arabia, appears to have had a prominent African lineage. According to al-Jahiz, the guardian of the sacred Kaaba, Abd al-Muttalib "fathered ten Lords, Black as the night and magnificent." One of these men was Abdullah, the father of Muhammad. According to tradition, the first Muslim killed in battle was Mihja, a Black man. Another Black man, Bilal, was such a pivotal figure in the development of Islam that he has been referred to as "a third of the faith." Many of the earliest Muslim converts were Africans, and a number of the Muslim faithful sought refuge in Ethiopia because of initial Arabian hostility to Muhammad's teachings.

The story of African presence in early Asia would be incomplete without an exposé of the Black role as servant and slave. The issue of African bondage anywhere is clearly one of the most sensitive and delicate historical issues, and all too often it is asserted that most, if not all, of the great international movements of Blacks occurred only because of slavery. As we have seen, this was not the case. What is important to emphasize in this context is that the period of Black bondage in Asian lands is only one part of a much wider story. The period of bondage is, in fact, dwarfed by the ages of Black glory and splendor in the Asian past. Even when enslaved or as freedmen, the Blacks of

Asia distinguished themselves time and again in a number of roles.

The ancient riverine civilization of the Indus Valley, named after one of its largest and most studied sites — Harappa — actually had extension reaching from the river Oxus in Afghanistan, in the north, to the Gulf of Cambay in India, in the south. The Harappan civilization flourished from about 2200 B.C.E. to approximately 1700 B.C.E. At its height, the Harappans engaged in regular commercial relations with Iraq and Iran. This much we know with certainty. We are equally certain that the founders of the Harappan civilization were Black. This is verifiable through the available physical evidence, including skeletal remains, eyewitness accounts preserved in the Rig Veda, artistic and sculptural remains, the regional survival of Dravidian languages (such as Brahui, Kurukh and Malto) and the essential role of these languages today in deciphering the Harappan script. We should also take into account the prominence accorded the mother goddess in Harappan cities and the sedentary nature of the Harappan people themselves. The Harappans cultivated cotton and perhaps rice, domesticated the chicken, and may have invented the game of chess and the windmill.

Exceptionally valuable writings, expressing intimate connections between early India, Egypt, and Ethiopia, have existed for more than 2,000 years. In the first century B.C.E., for example, the famous Greek historian Diodorus Siculus penned that "From Ethiopia he (Osiris) passed through Arabia, bordering upon the Red Sea as far as to India... He built many cities in India, one of which he called Nysa, willing to have remembrance of that (Nysa) in Egypt where he was brought up."[1] Apollonius of Tyana, who is said to have visited India at the end of the first century C.E., was convinced that "The Ethiopians are colonists sent from India, who follow their forefathers in matters of wisdom."[2] *Itinerarium Alexandri,* a Latin work written about 345 C.E. for the Roman Emperor Constantine[3] says "India, taken as a whole, beginning from the north and embracing what of it is subject to Persia, is a continuation of Egypt and the Ethiopians".

[1] *Diodorus of Sicily,* Bk.1, Harvard University Press, Cambridge, 1960.

[2] *Philostratus, The Life of Apollonius of Tyana,* Bk. 6, Harvard University Press, Cambridge, p. 71.

[3] Quoted in T. K. Joseph, "India: A continuation of Egypt and Ethiopia, *Journal of Indian History,* 26, 76-78, p. 201.

The term Dravidian is apparently derived from an Arya corruption of Tamil. It encompasses both a family of languages — including Tamil itself, Kannada, Malayalam, Telugu, and Tulu — spoken by more than 100 million people, and an ethnic type characterized by straight to wavy hair textures and "Black" complexions. The Dravidians are the living descendants, actual survivors, of the Indus Valley migrants who journeyed south into the interior of India. In 1288 and 1293, Marco Polo visited Dravida (South India) and left a vivid description of the land and its occupants. Polo wrote:

> The darkest man is here the most highly esteemed and considered better than the other who are not so dark. Let me add that in very truth these people portray and depict their gods and their idols black and their devils white as snow. For they say that God and all the saints are black and the devils are all white.[1]

India also received its share of African bondsmen. After their conversion to Islam, African freedmen in India, originally called Habshi from the Arabic, called themselves Sayyad (descendants of Muhammad) and were consequently known as Siddis. The term Habshi is derived from El-Habish, the Arabic word for the people of West Africa. Janjira Island, in the Arabian Sea, also was called Habshan, i.e. Habshan's or African's land.[2]

Siddi kingdoms existed in India from 1100 C.E. The Siddis were a tightly knit group, highly aggressive, and even ferocious in battle. They were employed largely as security forces for Muslim ships traveling on the Indian Ocean. The Siddi commanders were titled "Admirals of the Mughal Empire" and received annual stipends of 300,000 rupees. The Muslim geographer, Ibn Battuta wrote in the 14th century: "The Siddis are the guarantors of safety on the Indian Ocean; let there be but one of them on a ship and it will be avoided by the Indian pirates and idolaters."[3]

[1] M. Polo, The Travels, trans. R. Latham, Penguin, Harmondsworth, 1958, p. 276.

[2] K.K. Prasad, Siddis in Karnataka, Prasad, Bangalore, 1984, p. 72.

[3] I. Battuta, Travels in Asia and Africa, trans. H.A.R. Gibb, Routledge & Kegan Paul, London, 1929, p. 230.

It is possible that the largest percentage of Asian Blacks may be among the 160 million Untouchables or Dalits in India. The Untouchables number more than the combined populations of England, France, Belgium and Spain. The basic status of Untouchables in India has changed little since ancient times. The general literacy rate, for example, among Untouchables is only about 15 percent. Among Untouchable women, the literacy rate is below 7 percent. David Duke, a prominent white supremacist in the United States, claimed "that his 1970s visit to India was a turning point in his views on the superiority of the white race."[1] In addition, it has recently been observed that "Hindus do not allow Untouchables to wear shoes, ride bicycles, use umbrellas or hold their heads up while walking in the street."[2]

Untouchables in urban India are crowded together in squalid slums. In rural India, where the vast majority of Untouchables live, they are exploited as landless agricultural laborers and ruled by terror and intimidation. Numerous cases can be cited in support of this contention.

The Untouchables of India frequently are called Outcastes. The official name given to them in the 1951 Constitution is Scheduled Castes. M.K. Gandhi called them *Harijans,* meaning "children of God." Dalit, meaning "Crushed and broken" is a name that has come into prominence only within the last three decades. The word Dalit reflects a radically different response to oppression.

The Dalits are demonstrating a rapidly expanding awareness of their own African roots and have taken much of their heightened inspiration and direction from the literature and activism of African people at home and abroad. In April 1972, for example, the Dalit Panther Party was formed in Bombay, fashioned after the Black Panther Party in the United States of the 1960s. In August 1972, the Dalit Panthers announced that the 25th anniversary of Indian independence would be celebrated as a day of mourning. In 1981, in Bangalore, Dravidian journalist V.T. Rajshekar published the first issue of *Dalit Voice,* the major English journal for the Black Untouchables of India.

[1] E. Dutt, "India's Influence on David Duke, " *India Abroad,* November 22, 1991,

[2] V. Joshi, "Ancient Traditions plague the Untouchables," *Los Angeles Times,* August 5, 1990, p. A8.

Australia was settled at least 50,000 years ago by people who call themselves Koori and who are usually referred to as the Australian Aborigines. Physically, the Koori are distinguished by straight to wavy hair texture and dark to near Black complexion. In January 1788, when Britain began using Australia as a prison colony, an estimated 300,000 Koori were spread across the continent in about 600 small-scale societies.

Today, the Blacks of Australia are terribly oppressed, and they remain in a desperate struggle for survival. Recent demographic surveys, for example, show that the Black infant mortality rate is the highest in Australia. Aborigines have the shoddiest housing and the poorest schools. Their life expectancy is 20 years less than that of Europeans. Their unemployment rate is six times higher than the national average. They constitute less than 2 percent of the total Australian population. In the state of Victoria, the Koori have essentially ceased to exist.

Their resistance continues, however. In January 1972, an Australian Black Panther Party was formed in Brisbane. On July 16, 1990, an Aboriginal Provisional Government was launched.

Perhaps the Koori should consider themselves fortunate; the Black Aborigines of Tasmania were completely destroyed. Tasmania, an island only slightly larger than the State of West Virginia, lies 200 miles off the southeast coast of Australia. In 1802, following mainland Australia, Tasmania was established as a British prison colony, and the colonial government was not inclined to consider the Tasmanians as full human beings.

In a 1976 interview with *Black Books Bulletin*, Foreign Minister Ben Tanggahma of Papua New Guinea stated:

Africa is our motherland. All of the Black populations which settled in Asia over the hundreds of thousands of years, came undoubtedly from the African continent. In fact, the entire world was populated from Africa. Hence we the Blacks in Asia and the Pacific today descend from proto-African peoples. We were linked to Africa in the past. We are linked to Africa in the present. We will be linked to Africa in the future.[1]

[1]"West Papua New Guinea: An Interview with Foreign Minister Ben Tanggahma," *Black Books Bulletin*, 4(2) 1976, p. 54.

C. Madang described Melanesia, the Black islands of the South Pacific, as the eastern flank of the Black world and the expression of ages past when an uninterrupted belt of Black populations stretched across Africa, Eurasia, Australia, Oceania and ancient America.

Contrary to popular belief, the present Mongoloid inhabitants of Indonesia entered the region during relatively recent times, a period that some scientists have dated to as late as the first millennium C.E.. As was the case in Japan, the Philippines, China, Taiwan and Southeast Asia, the Mongoloid invaders found the land already occupied by long-settled Black populations. These new people eventually absorbed, vanquished or drove the Blacks into generally inaccessible areas, including the deep forests, high mountains and remote islands where many of them reside today.

By the 14th and 15th centuries, the Muslim Indonesian sultanate of Tidore was raiding the coasts of New Guinea in search of chattels for the markets of Turkey, Iraq and the Chinese empire. It is even said that the Malay term "Papuan," literally "kinky-haired," which was applied to the Melanesians of New Guinea, was born out of scorn and contempt and eventually became synonymous with the word "slave."

New Guinea is the largest and most populous of the Melanesian islands. Indeed, it is the largest island in the world, after Greenland. It is tremendously wealthy in mineral resources, including uranium, copper, cobalt, silver, gold, manganese, iron and oil. Now split in two during the colonial era, New Guinea has, until lately, contained a racially homogeneous population of five to six million Africoid people. The eastern half of the island became independent in 1975 under the name of Papua New Guinea, with Michael Somare as its prime minister. The western half of New Guinea, however, along with a significant portion of the total population of the island, which is estimated at three to four million people, has been seized by Indonesia as its 26th province.

For the people of West New Guinea, Indonesia has been and continues to be a brutal and aggressive occupying power. Under Indonesian rule since 1963, the Melanesians have been subjected to both physical and cultural genocide. Indonesians generally have a condescending view of Melanesians, whom they consider their racial inferiors — except, of course, those who turn away from their own culture and choose to identify with Indonesian cultural values, behaviour modes, etc.

Melanesians living in the forest communities of West New Guinea have been the victims of forced labor schemes, while in urban areas,

Melanesians face overt racial discrimination. A major part of the Indonesian regime's genocide policy is the physical replacement of Melanesians with Indonesian nationals. This poses the distinct possibility that the Melanesians of West New Guinea, like those of Fiji, could become a minority in their own country.

In 1963, for example, when the Dutch occupation of West New Guinea ended and control passed to Indonesia, the struggle for national independence accelerated. In that year, the Free Papua Movement (OPM, its Portuguese acronym) was formed. Interestingly enough, the Republic of Senegal early on provided its territory as a base for the international activities of the self-proclaimed Revolutionary Provisional Government of West Papua New Guinea.

Indonesian territorial aggression in Melanesia has not been confined to New Guinea. In 1975, for example, Indonesia formally annexed East Timor, a former Portuguese colony, as its 27th province. West Timor has been a part of Indonesia since Indonesian independence after World War II.

A Timorese national liberation movement, the Revolutionary Front of Independent East Timor (FRETILIN) was formed in September 1974, inspired by the revolutionary nationalism of African resistance leaders from other Portuguese colonies, including that of Dr. Eduardo Mondlane of Mozambique, Dr. Agostinho Neto of Angola, and Amilcar Cabral of Guinea-Bissau.

During the course of East Timor's national independence struggle, Indonesia has coordinated an unrelenting extermination campaign against the indigenous people. The invading Indonesian army has bombed, shot, tortured and starved the East Timorese, murdering more than 15 percent of the population. As recently as November 1991, Indonesian soldiers opened fire on an unarmed crowd at a funeral, killing 60 to 100 people. Despite adverse official reactions, none of the Western governments, including that of the United States, has imposed economic sanctions or adopted forceful policies against Indonesia to coerce its withdrawal.

New Caledonia, another mineral-wealthy South Pacific island, lies hundreds of miles to the southeast of Indonesia and is currently a French colony. Although the Black Melanesians of New Caledonia, known as Kanaks, are now said to constitute less than 50 percent of the total New Caledonian population, they were in fact native to the land 4,000 years before the French invasion of 1853. To the Kanak Socialist

National Liberation Front (FLNKS) of New Caledonia, the group of political parties that represents the majority of 64,000 Melanesians in New Caledonia, the principle of national self-determination is crystal clear. The Kanaks want their island to become an independent country, run by and for Melanesians.

The history of the African presence in ancient Asia spans more than 90,000 years and encompasses the largest single land mass on earth, yet it remains one of the least documented aspects of the global African experience.

There is more than enough documentation, however, to show that as the first modern humans and aborigines, creators of civilisation, sages and priests, poets and prophets, kings and queens, bondsmen and freedmen, African people have known Asia intimately from the very beginning. In addition to the African presence in Asian antiquity — the study of which is vital to the accurate and long overdue rewriting of world history — it is at least as important that we focus on the Black populations of Asia, Australia and the South Pacific today which, when combined, may exceed 200 million people

This highly capsulated introductory overview is offered as a contribution to the expanding dimensions of the African presence globally. The work is specifically dedicated to the Dalits of India, the Koori of Australia, and the Kanaks of Melanesia. The Dalits, probably the most oppressed people on earth, are engaged in a desperate and fundamental struggle for basic human rights. The Koori are fighting to stave off physical and cultural annihilation. The Kanaks have been confronted with the genocidal actions of aggressive foreign powers. These Black people are not only consequential members of the global African community but their current struggles are urgent, exceptionally severe, and deserving of the highest attention.

Communication to the United Nations[1]

Dr. Laxmi Berwa

July 25th, 1995.

Communication
to the Sub-Commission on Prevention of Discrimination
and Protection of Minorities
47th Session, August, 1995

Pursuant to Provisional Agenda Items 15 and 18

The following communication is submitted to the Sub-Commission concerning ongoing human rights violations suffered by the Dalits of India

Honorable Chairman and Members of the Sub-Commission:
I thank you for this rare opportunity to raise the issue of the long-standing and pervasive abuse of Dalit human rights before this distinguished body. This is the second time I have raised the issue of the Dalits before you. The first time was in August, 1982. Yet little has changed since then.

[1]Dr. Laxmi Berwa is a medical practitioner, and an activist of long standing on behalf of human rights for the Indian Dalits. As IHRAAM's Representative to the UN on behalf of the Dalits, Dr. Berwa submitted this communication to the 47th session of the UN Sub-Commission on the Prevention of Discrimination and Protection of Minorities.

As you may know, Dalits is another name for that ethnic group in India frequently referred to as Scheduled Castes or Untouchables, as well as by the patronizing label coined by the late Mahatma Gandhi, the "Harijan" (Children of God). The Dalits, so-called Untouchables or Scheduled Castes constitute 16% or 130-150 million of India's total population of approximately 900-950 million people. This is more than half the US population, and a little more than half the population of the former USSR. The Dalits have been victims of systematically sanctioned persecution by Hindu society since time immemorial. While Indians might well take great pride in their heritage and culture, the shameful fact remains that Indian Dalits continue to be systematically excluded from mainstream Indian society in all spheres of life, apart from their use as slave labor by high-caste Indian "touchables".

The following issues are of particular importance as it concerns the human rights situation of Indian Dalits:

a) *Untouchability.* While untouchability is officially abolished according to Article XVII of the Indian Constitution, the practice of untouchability remains part of daily living in Indian society. Any who do not observe this norm are either brutally murdered or otherwise forcefully shown their place in society. Since India's independence, many amendments and resolutions have been passed by the government, but their implementation has been extremely poor. The data compiled for 1981-1985 shows the number of cases registered under the protection of civil rights acts of 1955 has been ranging from 3,332 to 4,087. It should be noted that these are the cases that are registered in the police stations. Countless cases go unnoticed and unreported for fear of persecution.

Socio-cultural enforcement of the reprehensible notion of untouchability remains pervasive. I remember very vividly in high school and in college, the teachers would say, "You chuhra/chamar, go and do your traditional work." (Chuhra means sweeper and chamar means shoemaker or leather worker.) That is, go and sweep the streets, clean the latrines, make the shoes, take the hide of the dead animals and perform other slave labor and menial jobs. Some of them used intimidating tactics so that scheduled caste boys and girls would drop out of school or college, and not get an education. That Indian Dalits continue to endure even harsher measures to enforce their subjugation is clearly indicated by the fact that hardly a day passes without the Indian press, both national and regional, reporting instances of rape, murder, house burning, or social boycott of Dalits.

Many high caste persons argue that untouchability is no longer an issue. While untouchability may be loosening its grip in urban areas, only a small portion of the Indian and Dalit population live in the major cities; 80% of Indians and 80% of scheduled castes live in the villages, which are still the same cesspools of social injustice as they were centuries ago. Rural violence against the Dalits is a part of daily life. Even urban Dalits are not immune from violence. Even though the government has many rules and regulations on the books whose purpose is to protect the Scheduled Castes, their implementation has been derailed by high caste bureaucrats, politicians, police and other citizenry. The politicians and bureaucrats come to the scene of crimes, bemoan them, yet nothing is done.

b) *Atrocities.* The Ministry of Home Affairs started collecting statistics of crimes against Dalits in 1974, dividing these 'atrocities' into four categories: murder, grievous hurt, arson and rape. Later, the collection of these statistics encompassed all Indian Penal Code offenses in which Scheduled Castes/Scheduled Tribes were victims. For 1986, the data collected showed that the nature of crimes were as follows: murder, 564; grievous hurt, 1,408; rape, 1,002; other offenses, 11,750. A recent compilation of the cases of crimes against Dalits by Henry Thiagraj in his review, "The Wounded Society — Dalits of India," is provided in Table I. It is important to note that, despite the Untouchability Offense Act of 1955, the Protection of Civil Rights Act, 1976 and SC/ST Protection Act, 1989, all types of atrocities are continuing to be committed due to toothless departments and commissions. In its last report submitted to parliament for 1986-87, the National Commission for SC/ST concluded: "The failure of the police and prosecuting officers to discharge their duties effectively and promptly had resulted in the commission of atrocities with greater impunity." To make the matter worse, the culprits get away by prolonged disposition of cases brought to the court of law. As Anita Katyal writes in *The Times of India* (May 23, 1993): "SC/ST tormentors get away." Official figures for 1987-89 reveal that there were as many as 35,874 atrocity cases pending while the number of convictions was 14,718.[1]

The most recent incidence of ghastly crimes was on April 14, 1995 at Karuvanoor village near Madurai, during the birthday celebration of the late Dr. B.R. Ambedkar, when over 500 caste Hindus carrying lethal weapons, knives, and petrol, brutally attacked and injured hundreds of Dalits and burnt 68 houses.

[1] Human Rghts Education Movement of India, Madras, India.

TABLE I

	Year	# of cases	
1. Murder	1989	652	
	1990	691	
	1991	731	
	1992	556	(incomplete 6-9 mos.)
2. Arson	1989	754	
	1990	630	
	1991	645	
	1992	466	(incomplete)
3. Grievous Hurt	1989	1820	
	1990	1913	
	1991	1890	
	1992	796	(incomplete)
4. Rape	1989	1173	
	1990	1163	
	1991	1067	
	1992	1236	(incomplete)

Other crimes against Dalits under Indian Penal Code

Year	# of cases
1989	15023
1990	16880
1991	17029
1992	12797 (incomplete: some states reported 6 mos. and some 9 mos. only)

Total number of cases against Dalits - SC/ST

Year	# of cases
1989	19422
1990	21307
1991	21362
1992	13393 (6-9 mos.)

Source: 1992-1993 Annual Report, Ministry of Welfare, Government of India, presented in Parliament during Budget session, 1994.

The perpetrators of these atrocities were allowed to go free, but 46 innocent Dalits were taken into custody.

c) *Police atrocities.* Neither the Scheduled Castes and Scheduled Tribes Commissioner's report nor the Commission itself mention a word of crimes committed by the police against Dalits, not even first hand reports by Dalits against high caste individuals who committed crimes against them. However, while the officials, including police and politicians at all levels, state and federal, do not acknowledge the police as among the people who commit crimes against Dalits, one has simply to read the regional and national press to have an idea of it. I will cite just a few headlines in illustration: "Police atrocities on Dalit women — The Ropar Event" (1992). "Tamil Nadu government agrees to probe police firing on Harijans" (1992). "Police negligence in apprehending all the criminals — Fact-finding report of a rape case of a Dalit minor girl in Rajsthan" (1994).

In a recent letter to the editor of the internationally renowned Dalit fortnightly, *Dalit Voice*, Dr. K.R. Punia, I.A.S. (Ret'd) and a former Haryana industries minister, noted Dalit and Congress Party member, writes: "We submitted a memorandum to the Prime Minister on 10.5.1995 regarding police atrocities on the Scheduled Castes of Haryana. About 5,000 SCs led by me demonstrated at Jantar Mantar, New Delhi, and also courted arrest in protest against the inaction by the State Government. In one village, Butana, Sonepat dt., a Balmaki woman was tortured, fracturing her pelvic bones. Because of the police terror, half a dozen families have fled away. In another village of the same district, a 19-year old Dalit woman was raped and murdered. The police forcibly cremated the body at night and about 10 persons were booked wrongly when they objected to the cremation of the deceased at night, and tortured. All the SCs of this village have also deserted their homes and sought shelter elsewhere. We met the Haryana Chief Minister on 13.4.1995 in a delegation but he did nothing."[1]

How long can Dalits tolerate this situation? Many contend Dalits have every right to bear arms to protect themselves from high caste and police oppression. As a Dalit leader and member of parliament, Mr. Ram Dhan, warned: "Constitutional safeguards should be implemented or the nation will be crippled."

Insofar as India is a signatory to the Universal Declaration of Human Rights and other UN human rights treaties, it is recommended that the Sub-Commission on the Prevention of Discrimination and

[1] *Dalit Voice*, July 1-15, 1995,

Protection of Minorities send a fact finding team to India to get first hand information on the ongoing, pervasive and flagrant human rights abuses endured by the Dalits, and provide the Indian government with recommendations for the establishment of a credible system for Dalit human rights protection, as well as for monitoring the system's performance on a consistent basis so its effectiveness and success may be measured. While the government has plenty of rules and regulations for the protection of Dalits, it has not demonstrated the will to implement them, be it at the district, state or federal level. Since my first testimony in 1982, the number of atrocities has increased The government's lack of commitment is clearly demonstrated by the fact that it took seven years to appoint the new SC/ST commissioner, Dr. B.D. Sharma. Dalit issues are raised at election times in order to get Dalit votes; afterwards, there is a generalized apathy with regard to Dalit issues.

While a new systemic approach with regard to the Dalits may be necessary, surely a minimum requirement is to ensure the enforcement and implementation of existing laws, which may include the appointment of special courts to process cases which concern Untouchables and atrocities/crimes committed against them. In the entire union of India, only 6 out of 21 states have such specially appointed courts. This practice should be extended to all states. More Dalits need to be recruited as policemen and magistrates in crime-prone areas. Police need to be sensitized to Untouchability and crime issues. Victims need to be compensated, and the compensation indexed to the cost of living. A veritable public education crusade should be launched to sensitize high caste people to the plight and aspirations of the peoples at the bottom of the totem pole. The Dalits have a right to equality, even in a deeply prejudiced society such as that of India, and only the pressure of international organizations and world public opinion can galvanize the Indian government to a true commitment towards changing cultural attitudes which have been domestically acceptable for centuries.

I thank you again for the privilege of addressing this distinguished body, which I hope will look into this issue favorably for Dalits and intervene to protect these vast masses of people, who will be so grateful. A mission of the late Baba Saheb, Dr. B.R. Ambedkar, a messiah of the oppressed, especially the Dalits, will be fulfilled by your grace.

Dr. Laxmi Berwa, M.D., F.A.C.P.

HR 1425

Human Rights in India Act[1]

A BILL

To suspend United States development assistance for India unless the President certifies to the Congress that the Government of India has taken certain steps to prevent human rights abuses in India.

Be it enacted by the Senate and House of Representatives of the United States of America in Congress assembled,

SECTION 1. SHORT TITLE

This Act may be cited as the "Human Rights in India Act".

SEC. 2. FINDINGS

The Congress finds the following:
(1) In India, tens of thousands of political prisoners, including

[1]H.R. 1425, the "Human Rights in India Act," was introduced to the US House of Representatives, 104th Congress, 1st Session on April 6th, 1995 by Republican Representative Dan Burton. Of particular concern to Dalit activists, who have long labored for Congressional recognition of the human rights violations perpetrated in India against the Dalits, is item (10). [In the Indian Constitution, the Untouchables or Dalits are referred to as Scheduled Castes.] According to Dr. Velu Annamalai, this may be the first time that the plight of the Dalits has found a place in US Congressional records. Dr. Annamalai's assistance in provision of a copy of H.R. 1425 is gratefully acknowledged. Citations follow as per H.R. 1425/Briefing Packet.

prisoners of conscience, are being held without charge or trial under special or preventive detention laws.[1]

(2) The special and preventive detention laws most frequently cited by human rights organizations are the Terrorist and Disruptive Activities (Prevention) Act (TADA) of 1987, the National Security Act of 1980, the Armed Forces (Punjab and Chandigarh) Special Powers Act of 1983, the Armed Forces (Jammu and Kashmir) Special Powers Act of 1990, and the Jammu and Kashmir Public Safety Act of 1978.[2]

(3) These laws provide the military and police forces of India sweeping powers of arrest and detention with broad powers to shoot to kill with virtual immunity from prosecution.[3]

(4) These laws contravene important international human rights standards established under the International Covenant on Civil and Political Rights, to which India is a party, such as the right of liberty and security, the right to a fair trial, the right to freedom of expression, and the right not to be subjected to torture or arbitrary arrest and detention.[4]

(5) Throughout India. political detainees are often held for several months, and in some cases a year, without access to family, friends, or legal counsel.[5]

(6) Throughout India, the torture of detainees has been routine, and scores of people have died in police and military custody as a result.[6]

[1] Amnesty International Report, 1994, p. 157, paragraphs 1 & 5. Human Rights Watch World Report 1995, p. 155, paragraph 2.

[2] Amnesty International Report 1994. INDIA: Torture and Deaths in Custody in Jammu and Kashmir. Amnesty International, Jan., 1995. INDIA. Human Rights Violations in Punjab: Use and Abuse of the Law. Amnesty International, May, 1991.

[3] INDIA: Torture and Deaths in Custody in Jammu and Kashmir. Amnesty International, p. 46, paragraph 3.

[4] INDIA: Torture and Deaths in Custody in Jammu and Kashmir. Amnesty International, p. 46, paragraph 3; p. 48, paragraph 1.

[5] INDIA: Human Rights Violations in Punjab: Use and Abuse of the Law. Amnesty International, May 1991, p. 49, paragraph 3.

[6] Amnesty International Report 1994, p. 157, paragraph 1.

(7) Throughout India, scores of political detainees have "disappeared" and hundreds of people are reported to have been extrajudicially executed by military and police forces.[1]

(8) In Punjab, the Punjab Government encouraged extrajudicial executions by offering bounties for the killing of militants and paid over 41,000 such bounties between 1991 and 1993.[2]

(9) Abuses by the military and police forces of India are particularly widespread in the states of Punjab, Assam, Manipur, Nagaland, and the portion of the disputed territory of Jammu and Kashmir under the control of the Government of India.

(10) Many victims come from underprivileged and vulnerable sections of society in India, particularly the scheduled castes and tribes.[3]

(11) The establishment of the National Human Rights Commission by the Government of India is an important first step toward improving the human rights record of India.[4]

(12) However, many human rights organizations are deeply concerned about the severe limitations placed on the powers, mandate, and methodology of the National Human Rights Commission.[5]

(13) In 1994, the decision by the Government of India to allow the International Committee of the Red Cross to provide limited humanitarian assistance in the portion of the disputed territory of Jammu and Kashmir under the control of the Government of India was an important first step in providing international humanitarian organizations greater access to troubled areas of India.

(14) However, in 1994, the Government of India continued to prohibit several international human rights organizations from conducting independent investigations in the portion of the disputed territory of Jammu and Kashmir under the control of the Government

[1] Amnesty International Report 1994, p. 157, paragraph 2.

[2] State Department's Human Rights Report for 1993, India section, p. 1340, paragraph 4.

[2] Amnesty International Report 1994, p. 158, paragraph 1.

[3] Amnesty International Report 1994, p. 157, paragraph 5.

[4] Amnesty International Report 1994, p. 159, paragraph 11.

[5] Human Rights Watch World Report 1995, p. 156, paragraph 5.

of India and provided only limited access to such organizations to other states such as Punjab, Assam, Manipur and Nagaland where significant human rights problems exist.[1]

(15) In India, armed opposition groups have committed human rights abuses.[2]

(16) Several human rights organizations have called on such armed opposition groups to respect basic standards of humanitarian law which require that individuals not taking part in hostilities should at all times be treated humanely.[3]

SEC. 3. LIMITATION ON DEVELOPMENT ASSISTANCE FOR INDIA UNLESS CERTAIN STEPS ARE TAKEN BY THE GOVERNMENT OF INDIA TO IMPROVE HUMAN RIGHTS IN INDIA

(a) LIMITATION. — The President may not provide development assistance for India for any fiscal year unless the President transmits to the Congress a report containing a certification for such fiscal year that the Government of India meets the following requirements:

(1) The Government of India has released all prisoners of conscience in India.[4]

(2) The Government of India ensures that all political prisoners in India are brought to trial promptly and fairly, or released, and have prompt access to legal counsel and family members.[5]

(3) The Government of India has eliminated the practice of torture in India by the military and police forces.

(4) The Government of India impartially investigates all

[6] Human Rights Watch World Report 1995, p. 156, paragraph 5. Amnesty International Report 1994, p. 159, paragraph 12.

[2] Amnesty International Report 1994, p. 157, paragraph 1.

[2] Amnesty International Report 1994, p. 160, paragraph 3.

[3] Amnesty International Report 1994, p. 159, paragraph 7.

[5] Amnesty International Report 1994, p. 149, paragraph 7.

allegations of torture and deaths of individuals in custody in India.[1]

(5) The Government of India has established the fate or whereabouts of all political detainees in India who have "disappeared".[2]

(6) The Government of India brings to justice those members of the military and police forces responsible for torturing or improperly treating prisoners in India.[3]

(7) The Government of India permits citizens of India who are critical of such Government to travel abroad and return to India.[4]

(8) The Government of India ensures that human rights monitors in India are not targeted for arrest or harassment by the military and police forces of India.

(9) The Government of India permits both international and domestic human rights organizations and international and domestic television, film, and print media full access to all states in India where significant human rights problems exist.

(b) REQUIREMENT FOR CONTINUING COMPLIANCE.— Any certification with respect to the Government of India for a fiscal year under subsection (a) shall cease to be effective for that fiscal year if the President transmits to the Congress a report containing a determination that such Government has not continued to comply with the requirements contained in paragraphs (1) through (9) of such subsection.

(c) WAIVER.— The limitation on development assistance for India contained in subsection (a) shall not apply if the President transmits to the Congress a report containing a determination that providing such assistance for India is in the national security interest of the United States.

(d) DEFINITIONS.— As used in this section:

[1] Amnesty International Report 1994, p. 159, paragraph 7.

[2] Amnesty International Report 1994, p. 159, paragraph 9.

[3] Amnesty International Report 1994, p. 159, paragraph 7.

[4] State Department Human Rights Report for 1994, India section, p. 1228, paragraph 2.

(1) DEVELOPMENT ASSISTANCE.— The term "development assistance" means assistance under chapter 1 of part I of the Foreign Assistance Act of 1961 (22 U.S.C. 2151 et seq.).

(2) INDIA.— The term "India" includes the portion of the disputed territory of Jammu and Kashmir under the control of the Government of India.

(e) EFFECTIVE DATE.— The prohibition contained in subsection (a) shall apply with respect to the provision of development assistance beginning 9 months after the date of the enactment of this Act.

DALIT SAHITYA AKADEMY BOOKS IN ENGLISH

(25 per cent com. on bulk purchases,
No VPP, full set costs 50.00)

Subscribe to *Dalit Voice*, English fortnightly,
the Voice of the persecuted minorities,
Rs. 45 : India—25 US Dollars foreign

DALIT SAHITYA AKADEMY
109/7th Cross, Palace Lower Orchards
Phone : 363854 Bangalore – 560 003. India

AN OPEN LETTER

DATE: _____

V.T. Rajshekar, Director
Dalit Sahitya Akademy
109/7th Cross
Palace Lower Orchards
Bangalore 560 003 India

Dear Mr. Rajshekar:

I have been deeply moved to learn of the terrible plight of the Dalit people in India.

I urge the Government of India and the United Nations to take every possible action to erase this appalling blight on the conscience of the world.

Sincerely,

(signature)
NAME: _____
ADDRESS: _____

My donation of $_____ in aid of your efforts is enclosed.

Please send me the following Dalit Sahitya Akademy books. My check in the amount of $_____ is enclosed.

